For Martina

Contents

This book is about us.

It's about how we all have the ability to be powerful.

I wrote it because I became fed up with the old story that artists are incapable of affecting the real world.
 I wrote "Art And Courage" not just for when we are feeling strong and grand, but also when life unfolds with its whole heavy agenda and we question why we are alive.

I wrote it for you, for today. And I wrote it for you, for your life ten years from now.

I wrote it for me, to slap myself silly.

ART AND COURAGE

Realization

Courage always starts out by feeling like fear. Fear is an invitation for us to respond with belief in ourselves. Like the seeds of a dandelion flower blown by the breath of a child, we never know where our acts of courage will land or how far they might reach. Art can be the fuel for courage in ourselves and for those we touch.

I taught art at a school for troubled youth. I worked with many memorable students but would never forget a thirteen year old boy named Garett. He was a handsome kid with warm brown eyes which could quickly transform into venomous black slits when he was angered.

At unpredictable times during the school day, Garett would become enraged to the point of being destructive. Occasionally, he became so violent that a crisis intervention team would have to remove him from my classroom. We all spent many tough afternoons with him while he was being restrained on the floor of a padded room. The school tried parent conferences, special education programs, counseling and medication. Nothing seemed to help him.

One morning without warning, Garett leapt out from his seat and physically attacked me. I had to evacuate my other students while he completely wrecked the classroom. When the police came, they had to handcuff him and it took three grown men to remove him from the room. My last image of this kid was of him being carted away, screaming obscenities at me and telling me how he had wanted to kill me. The memory of this hung over me like a dark cloud. I had failed with this child like no other child I had ever worked with. My once complete sense of effectiveness was eroded. Although I moved on and successfully interacted with hundreds of other students, I carried a private wound within me because of Garett.

Six years later, I had changed careers. I was the confident director of a large private art school. Our studio had clear plate glass windows that looked out onto the street. One day, as I sat at the main desk in the lobby, a tall hulking male figure came through the door. He spoke: "I know you."

My mind quickly ran through the files of its memories and my blood froze when I looked up to meet his gaze. The darkness came back to me. It was him. It was Garett.

He was walking slowly towards me, pointing at me. His eyes were wide.
"I know you," he repeated again. "You were my art teacher. Do you remember me?"
Numbers shot through my head. I thought of the number of years it had been since I had seen him being dragged away by the police. That little kid was nineteen years old now. He

4

was muscular and stood six inches taller than me, I guessed. I also thought about dialing the police discreetly, while I sized him up. As he loomed over my desk, detailed memories of the past obviously began rushing back to him as well. My mind conjured an image of what surely would happen next. He had found me and now he would resume unfinished business. My eyes took stock of anything in the room that could be used as a weapon of defense against him in case of an emergency.

I smiled as broadly as I could manage. "Yes, Garett," I answered. "I remember. How are you?"

His familiar brown eyes suddenly softened as a flood of emotion animated his face. "Mr. Thornton, I always wanted to thank you. You were the only teacher I ever had who cared about me." I sat in stunned silence. No words came to my lips.

Garett continued excitedly, "I'll always remember that time you taught me how to draw super-heroes." My mind was blank. What was he talking about? Why wasn't he leaping over the desk to try to strangle me? Had I ever drawn Super-heroes with him?

"I still remember how you showed me to start with an oval for the head and how to draw the muscles and the costumes." With his arm he traced the shapes in the air. He smiled now. "I always remembered you showing me how to draw cool things." Suddenly, I did remember what he was talking about. One afternoon when Garett was especially destructive and unreachable, he had to be restrained by four professional faculty members in a padded room. They had his arms and legs pinned to the floor as he laid on his stomach. I had been called to help distract him until his parents could come

to pick him up. I crouched on the floor for an hour while I entertained him with cartoon doodles on a piece of notebook paper. Now, here before me stood the same person, grown from a boy to a young man.

Garett and I talked for a long time about recollections of the art projects we did while I was his teacher. He proudly reported that he had managed to graduate from high school and had started his first year of college. "Things are going well for me now," he said. He shook my hand and told me again how glad he was to have run into me.

When Garett left, the dark cloud that I had been carrying for six years left as well.

That day was a gift for me. It reminded me of the ability art has to create focus. On that forgotten afternoon six years earlier I used art as a tool of diversion. It served as a kind of medicine for him and at the time, it was also a shield for me- a bit of sanity that I had clung to for my own protection. Art had empowered me to have an effect on this youth, to help us both find a place of dignity and peace.

This was the first time that I realized the invisible power of art. It was also the first time I could reflect upon and understand the misconceptions about my true abilities. As a painter, my art exhibitions and dealings with galleries were very important to me. Yet here was proof that the other dandelion seeds I had been putting out into the world possessed an energy that I had not even imagined. In the case of Garett, a few doodles on my notebook paper were actually charged with the ability to strengthen and protect both participants in an emotionally charged situation. I noticed that in our conversation, Garett had

not spoken about episodes of anguish and outbursts of violence of his youth. Instead, he recalled the creative, focused play that our little drawings provided. They were like harbors of shelter during storms. Following our unexpected meeting, I realized that something powerful and profound had happened between us in that place of darkness all those years ago: We had both used art to overcome fear.

I might have simply filed this story away in my mind, as a feel good encounter to mend my long-bruised ego. Yet the reverberations of this new understanding would not fade. A part of me woke up to knowledge that I could not ignore, and two questions began to weigh upon my mind and heart: What powers could my art have if I would only activate it as a tool? How powerful could I be, and how powerful could all artists be once we understood and believed in our true capabilities to impact the world around us? Once I was conscious of this overlooked potential, my relationship with art evolved into something new. I had new aspirations. "Art" was no longer confined to my paintings on canvas, but now seemed to spill out into real life in a way I had not expected. I began to seek out examples of other creative people who had also used art as a tool for creating strength in their lives. I found that I was not alone.

 *"Be not daunted , nor terrified, nor awed
by the radiance of your own true nature.
Recognize it. From the midst of that radiance,
reverberating like a thousand thunders
will come the sound of your own real self."*

—Traditional Tibetan text

The Potential Strength That Artists Possess

This is not the time to whisper. It is a time a use our voices, clearly.

Events in the world are challenging us to rethink our direction and priorities. Images on our television and computer screens depict news that is far removed from the ideals that we might wish for. And in the midst of this time, we are creators. We are artists.

All of us, in our lives, are going to be confronted by questions of a very worldly nature. Questions about the wisdom of what we will do, how we will proceed, and why.
You know these questions. Only now, they are taking on a new kind of urgency.

You can have a great impact on the world... greater than you think. Artists are the secret keepers of a gift. Artists sense the world differently. You can form imaginative solutions and can benefit from our connection to a great lineage of individuals who have been identified as being different from others. The benefit is that, because we are separate from the group, we may more easily become leaders.

9

It is inspiring to see how a few creative people from our recent past were able to change the world we live in through their vision. The ones who make our hearts pound appear to have acted in spite of fear of failure and they were often the subject of many forms of criticism. What compelled them? What is their message to us today?

The Potential Strength That Artists Possess

 *"The only cats worth anything
are the cats who take chances."*
—*Thelonius Monk, Musician*

Audacity

In 1780, a young French painter named Jean Germain Drouais returned home to Paris after studying in Rome. Drouais was asked by the Parisian Art Academy to present a humble copy of an old masterwork as proof that he had spent his stay in Italy wisely. At the time, all good students were required to dutifully copy a painting and deliver it to their professors as a final step towards earning their certificate of graduation. Drouais was different. He chose not to submit an obligatory copy to the Academy. Instead, he announced that he would be submitting a billboard-size original painting of his own design and making.

The esteemed members of the French Academy were flabbergasted by the painter's arrogance. They refused the brazen offer. Furthermore, they would not let him graduate. Drouais responded courageously by displaying his painting in the parlor of his family home. This well publicized act of defiance drew all the Parisian intellectuals to view the scandalous artwork. Even Thomas Jefferson who was visiting from America, joined the intrigued crowds who stood in line to experience one of European history's first artist-launched independent exhibitions. After much back-peddling and discussion, the Academy ultimately permitted Drouais to graduate. Today his huge painting, "Marius at Minturnae" hangs proudly at the Louvre Museum in Paris.

Sixty years after Drouais' act of audacity, Paris continued to
reign as the culture capital of the world. Many talented artists
were dedicated to working in the traditional style of the day,
Neo-Classicism, where figures of graceful balance were favored
by the tastemakers and scholars. A smooth surface was achieved
by these Neo-classical painters who meticulously softened
and eliminated their brush strokes so that they would not
blemish the sense of perfection that mirrored the legacy of
the great Emperor Napoleon and his dynasty. Yet, a certain
painter in France named Gustave Courbet did not work the
same way everybody else did. He did not wish to depict a
smooth, antiseptic view of the world. Instead, Courbet tried
to paint things as they actually appeared in life. The curators
of the formal annual salon show did not look favorably upon
his pictures. To them, Courbet's art seemed too raw and out
of place among all the other artist's depictions of polished
Goddesses and dainty lyrical landscapes. Corbet painted with a
palette knife, leaving thick textural marks on his canvases. His
style was considered vulgar. The curators snubbed him. They
simply did not invite Courbet to exhibit.

Instead of letting the rejection of his work defeat him, he did
something remarkable. He erected a large building in the
middle of the city, where he displayed his gigantic paintings.
He called his alternative exhibition "Gustave Courbet's Pavilion
of Realism." It opened the same week as the official art salon.
Crowds of people came to see his work, which helped Gustav
Courbet become a notorious celebrity. Today, his two greatest
wall-sized paintings, "Burial at Ornans" and "Portrait of the
Artist at Work in his Studio" now occupy the central hall of the
elegant Musee d'Orsay in Paris.

In 1874, a new generation of young artists in Paris found that they, too, were experiencing similar barriers when it came to exhibiting their paintings within the confines of the official art world. After forming a group, a handful of them decided to put on their own show at an alternative venue. Where would they find a gallery willing to help them? They approached their friend, Nadar, who owned a camera studio, and asked if they could use his place and hang some of their paintings on the walls. He said yes. The camera studio seemed an odd place for an exhibition of paintings, but it had the distinction of being just around the corner from the very upscale Paris Opera House. It was also directly across the street from the most elegant café in the whole city, Le Café de la Paix. The artists anticipated that upscale opera-goers would in be close proximity to their show as they stopped by the Café and would thus be able to visit the exhibition more easily than if it were held in the artists' home neighborhoods. The group of artists wisely sent out press releases and placed their own ads in newspapers. When the exhibition opened, people lined up to view their strange new style of painting. Some of the viewing public responded negatively and the artists even considered posting guards to protect the exhibit and to keep their canvases safe from being vandalized.

Although a dismissing critic blasted the group by calling them merely "Impressionists", these artists gained much acclaim from their courageous independent exhibition. They held one annually for the next eight years, which cemented their reputations, making them all world famous. Claude Monet, August Renoir, Edgar Degas, Mary Cassatt, Camille Pissarro,

Berthe Morrisot, Paul Gaugin and all the other independent painters might have possibly worked in obscurity if they had not dared to make the first move themselves.

During the dark years of World War I in Zürich, Switzerland, a new group of playful artists and writers gathered at a local club known as the Cabaret Voltaire. They produced kooky, startling events and stage shows that challenged the accepted standards of the day. No gallery or respectable venue would have anything to do with them, but their self appointed spokesperson, Tristan Tzara, was an active member of the group and a bold, articulate writer. He published a newsletter with reviews and articles about his friends' new made up art movement, which they called..."Da-Da." They explained that Da-Da was one of the sounds that an infant would make when referring to a toy horse. The Da-Da artists believed that art had to be reborn in a child-like way to cleanse itself in the face of mankind's madness. The international press picked up on these verbose, clever articles and the Da-Da activities became famous. We must keep in mind that the now famous Cabaret Voltaire was not a large professional performance hall. In fact, it was a glorified coffeehouse, maybe the size of a modern Starbucks. The "Da-Da" movement later grew to become the "Surrealist" movement, which counted among its members Pablo Picasso and Salvador Dali. Both art movements defined the visual style of the 20th century and were launched by artists who were courageous enough to not only break strict artistic rules but to also take control of their own careers. They connected and compelled.

These artists' names are dripping with fame today. But we should not be distracted by that. Let us instead view these individuals simply as people who had the will to bring about events to their advantage. They risked censure, ridicule, professional embarrassment and financial loss to boldly make their personal statements. This risk was the key. That is what activated their power.

Understand your lineage. We do not know for certain how the first skilled cave painters were looked upon by their tribes. But we know that most artists throughout the world's recorded history have held the humble status of artisan, or worker. According to the social customs of the ages, artists- even while creating revered temples and items used for worship- were considered laborers, hardly different from shoemakers or brick-layers. (Actually, shoe makers and brick layers were perhaps deemed more useful than artists. In some cases, today they still are). Even while possessing a practiced skill, the very fact that artists worked with their hands gave them a position low on the food chain. Armies of these anonymous artisans gave their lives to build the world's pyramids and cathedrals. Countless craftsmen carved the world's sculptures and illustrated the thousands of religious manuscripts we now hold so dearly.

The very notion of an artist signing their name on an artwork is relatively new, while the Western image of artists possessing some kind of "power" or "vision beyond normal people" evolved hesitantly and was bestowed upon only a handful of Renaissance luminaries, usually for their connection to the Church or the direct glorification of the papacy.

In Europe, during the Romantic period in the mid eighteenth century, the new image of artist as "social commentator and poet" was born in the public imagination, accompanied with no small amount of scorn and fear. By the beginning of the twentieth century, the potential status of an artist had completely inverted from its origins. Instead of working anonymously, suddenly art movement after art movement exalted the creative individual who tended to work with a sheer disregard for "the tribe". This contemporary image of the artist reigned for over a century, as long as it served the market place, the dealers and critics…

In all of these epochs, the artist was viewed as an outsider, either below or beyond the rest of society.
But artists are hearing a new calling now. There is a new way of approaching art that fits perfectly into our present time.

Audacity

"Vision is not enough.
It must be combined with venture.
It is not enough to stare up at the steps-
We must step up the stairs."

—Vaclav Havel, Playwright and Politician

Your Vision of Yourself

What kind of creator are you now?

And...what kind do you wish to become?

The possibilities can blur together. They are interchangeable and may rearrange in different cycles throughout your life. You could become a student many times over. You may embrace art as a money-generating field, and have a fulfilling career for yourself in one of its many forms. You may use it as a means of pure self-expression to document your visions.
Art may save your sanity or fade and return in the nick of time, giving you a shot of hope. Art can entice creative people to work alone for years, hiding their power. After a time of darkness, art can revitalize your entire view of the world, giving you confidence and joy. Then the variations may repeat.

Art is likely to do all of this in some way before your path is complete.

Events in the world seem to be challenging us to respond in meaningful, immediate ways. Artists and creative people in all fields are experiencing a sense of urgency to manifest their powers to construct a better reality. We want to feel ready to

trust ourselves to act, even if we are not yet sure how.

Take a moment to remind yourself about the power art has had in your life since childhood. The memory of that feeling of art as a shelter, an escape, or a joy is more than just a distant or habitual longing: it is your built-in homing device. If you have lost that power over time, or if it changed into a bland version of its former joy, do you want that power back? If you presently hold it intact, are you now ready to really activate it?

Let's start here in the present. Before we can entertain this romantic notion that we might be respected by or even be able to make a dent on the world we have an important commitment to keep with ourselves. If we are not to be slaves, we must learn to first serve ourselves and our hearts when we create. This commitment is a form of courage that can be very intense to confront. It can have great repercussions on our lives, the lives of our loved ones, and our ability to grow as people. The commitment is simple when written. The commitment is electric when uttered aloud. It is the commitment of the ages that binds the brave and creative together across time. The commitment goes something like this:

> *"I am a powerful creator.*
> *My art has meaning to me and to others.*
> *I will create art for my own time.*
> *Art carries through every aspect of my life.*
> *I continue to explore, enhance,*
> *tear-down and rebuild myself*
> *...and I will never stop."*

Your Vision of Yourself

 *"Turn to Face the Sun,
and the shadows fall behind you."*
-*Traditional Maori proverb*

Artistic Archetypes

I love learning about how great artists kept their dreams alive. All of the other information gathered in art history books used to classify and pigeon-hole schools of creativity is of little use to us. If we can weed through the mountains of distracting data that bogs down art history, we may discover afresh that all the great artists have deeply meaningful lessons to share with us about their commitment.

Individual stories about artists are marvelous and often dramatic. Yet in the minds of many of us, there exists a pervasive "archetype" of who the artist is supposed to be. The word archetype refers to a primordial image, a character that recurs throughout literature and thought consistently enough that people consider it to be universal. The term was adopted by literary critics from the writing of the psychologist Carl Jung, who formulated a history of the collective unconscious. Basically, there is a universal way that our cultures expect artists to behave.

We know that artists' lives are as varied as those of any other people's, and yet, in our culture, a great mythology has risen around the artist archetype. This mythology often depicts a victim-like personality, where the artist is made

25

to be an outsider to the rest of society. Alternatively, the mythology often depicts the artist as an aloof genius, yet again disconnected from the real world. Both archetypes are ultimately inaccurate and crippling. They are part of an old story, that needs to be retold in a new way.

In reality, the lives of artists are based upon something quite remarkable: They are a blueprint of faith. We can study the life stories of so-called "famous" artists to discover this blueprint for ourselves, to see how courage played a role in their unfolding destinies. As we review these stories, let us take a decidedly dry-eyed look at the mythology. Let us bypass the familiar romantic trappings and the usual archetypes. Instead, let us focus on the basic environments, circumstances and choices which led these people to act with conviction.

Take the art of painting. In my mind, the most inspiring works of painting are not the gigantic religious altar pieces commissioned by the church. Nor are they the glorious military pictures which illustrate Napoleon defeating Austria, George Washington crossing the Delaware River, or some such action-hero embarking upon a propaganda tour. However well executed, those huge paintings would undoubtedly have been made by someone, somehow. Institutional images like that have so much political and financial support behind them, that they require minimal personal risk in their making.

The paintings I love are more personal and could only have been made by the will of an individual. Forget the dates, scholarly essays and reverential celebrity that

accompany so much fine art. Look closer and you will discover that the museums of the world are filled with creations which are like little pages from intimate diaries. Each proclaims, "I believed."

For instance, here's the story of the famous painter, Rembrandt:

There was a talented child who grew up as the son of common workers. He attended art classes and learned solid craftsmanship. As a teenager he surpassed his teachers. He opened up his own studio and soon had dozens of students learning how to paint just like him. Fortunately, he lived in a big city with a lively shipping port, which drew trade and wealth from all over the world. This particular painter did quite well commercially. He married a sweet young girl, and lived in a stylish home in a fashionable neighborhood. Although he did not like traveling much, he was exposed to many wonderful ideas and patrons. Life was grand.

Yet as time went on, the artist's fortune shifted. Many of his well-trained students became professionals themselves. They mimicked his style and received many commissions that might otherwise have been his. As bills rolled in and work became scarce, the artist was forced to sell his posh home, his furniture and art collection. The artist's wife became ill, and died after giving birth to a son. A collection agency made the artist liable for all of his debts. He would soon have to begin turning over all of his own paintings to his creditors in lieu of cash. His smart housekeeper had an idea! She discovered a loophole in the law stating that the debtor could

retain his paintings, but only if he used them to pay rent to a landlord. She suggested that the artist proclaim her and his son as his "Landlords." In this way he could at least keep his own artwork and a shred of dignity. While living in poverty for the next decade of his life, the artist bravely turned towards creating expressive personal imagery. With nothing left to lose, he practically reinvented the art form of oil painting. He died penniless. But upon his easel sat an unfinished canvas, shockingly innovative, reflecting the passion and devotion he carried up until his last days. It was auctioned off by bill-collectors.

The artist's reputation waned, so that, a century later, he was ranked to be one of the most disdainful of all painters. Yet opinions changed and he is remembered today as one of the greatest artists to have ever lived.

The above story certainly reads like a myth or a faerie-tale. The young talented artist rises to great heights, experiences hardship and falls into poverty. At the end, their reputation is redeemed. It is classic in its flow. But make no mistake: the romanticism about Rembrandts rise and fall does not serve us in any way beyond wallowing in gossipy dramatics. The fact that this artist experienced success (and even fame beyond death) is still not the point. The most important message to the story is the fact that the artist was able to carry on while darkness befell him. He found wonder in his own homely face, painting it from his reflection in the mirror, in times of wealth and in times of despair. It was his inward turning that gave him the grounding to continue painting through times of great loss. Not only

did he simply carry on, but he continued to create powerful expressive works until the end of his life.

Understand that life requires us to take action differently, in different phases along our journey. We may go through our days quietly preparing for the distant moment when we must summon strength and commitment to the things we hold most dearly. If we have not let the notion of the powerful artist into our mind for consideration, how will we ever be able to call upon it when needed? Will we be able to function, not just artistically, but with concentration and dedication? When the time comes in our life to make a decision, embark upon a new project, re-launch a career or trust our artistic decisions, we must be able to act. Knowing how to discern the meaning of these stories helps remind us of our ability to carry out our own full measure of power.

Here is another story, based on the life of American impressionist Mary Cassatt:

There was a young woman who was blessed to be born in a very wealthy family and in a very wealthy country. She was showered with lavish material things, yet maintained a great interest in learning how to draw and paint. She was privileged to study art in with the intention of becoming a painter of portraits. Along the path, she ran into some artists who were considered by some to be "the wrong crowd". She realized in her heart, however, that these artists were not simply rebels, but pioneers. She also had the courage to realize that she herself was a pioneer like them. She risked professional

ridicule by exhibiting with them, and even helped to finance the exhibits for them. When offered prizes and awards, she politely but firmly refused them on principle. She never married or gave birth, yet devoted her life to creating her personal imagery which depicted the maternal spirit and the beauty of children.

Here is a story quite different from the victim archetype: Mary Cassatt "comes down" from her social level to find truth in the ideals of "rebels". She plays an instrumental role in their shared success. She is an outsider, who helped fellow outsiders become the most popular artists in history.

Mary Cassatt, who never married or bore children herself, is known for her wondrous mother and child paintings. In her art, she becomes expert at depicting a subject which she observes from afar, but is not a direct participant in. Perhaps no other artist has ever come close to portraying the joys and sensations of motherhood like her. By being an impassioned observer of friends and nieces, she brought a new honesty and candidness to their roles and experiences.

Now another story reflecting the life of famed Dutch painter, Jan Vermeer:

There was a young lad who had studied hard to become a professional artist. His teacher was suddenly killed in a tragic explosion, and all eyes turned to this young artist with great expectation. He was called "A phoenix who will rise from the ash" of his deceased mentor. Yet Vermeer would

not feverishly produce huge wall-sized canvases. Nor would he produce hundreds of masterpieces like so many geniuses did before him. His life took a far less dramatic path. He married and had to earn enough money to support his many children. To do this, he had to take a day job as the manager of an inn. With limited time, he was only able to produce a handful of small paintings. Yet with steadfast clarity, he ensured that every artwork was as strong as it could be. Centuries after his death, he was rediscovered and heralded as one of the greatest painters to have ever held a brush. His precious few artworks are considered among the most quietly profound and poetic of all time.

What is the message of Vermeer's life? The challenge to create and adapt one's art to one's life on a day to day basis is vital. Family obligations need not take away from the final quality of our work.

Searching for the essential message in a story is a game that can be played when we want to understand how precious our own gifts are. With all the distracting details stripped away, a story clearly holds value for us. It teaches us about possible setbacks we may experience and the outcomes that we may create along the path of our own life-story.

Beyond personal vision and technique, a series of choices and events acted upon give a life its greatest potential for meaning. Keeping the door open to change and possibility is the greatest act we can make to invite forces of growth to take root. High drama need not be the breeding ground of courageous acts.

In it's humblest form, courage comes into play by accepting a new job, learning a new skill, or moving to a new position, physically or symbolically. When we complain about or are dissatisfied with our current situation or position, we are always capable of creating a change that will call forth a new series of life altering circumstances. The feelings of discontentment are indicators that change is necessary, although it may be difficult to believe that expansion is even possible. All we have to do is hit the first domino and be led by a dream in which we have passion. That is the meaning of faith: to have belief in the invisible.

As a working artist myself at the dawn of the 21st century, I am rejecting the tired archetypes of the "artist as victim" and "artist as disconnected genius." I am in favor of new archetypes:

The artist as the living embodiment of dedication.
The artist as the great teacher.
The artist as the healer.
The artist as the warrior.

Artistic Archetypes

*"The barriers are not erected
which can say to aspiring talents and industry,
"Thus far and no farther."*
—*Ludwig van Beethoven*

The Red Car

James Venable was working as a wedding DJ.

He had always loved music with a passion. Growing up with his Grandmother, he received much encouragement and support through his school years. In his youth he played in bands, and went on to study advanced systems of musical composition.

Many artists take on part-time or alternative jobs to make ends meet until their greater dream of "making it" becomes a reality. He too had such aspirations, and while he waited for his dream to manifest, James took his DJ Business seriously. He understood that it was his job not simply to play music at the receptions, but that it was his responsibility to play the right song at the right time so that guests remained actively involved and participating. He took real pride in making sure that his programs were filled with fun and high energy while at other appropriate times, he would introduce slower-tempo songs to the program. By observing the dynamic of the crowd, he would fit the song to the mood of the moment. This was after all, according to James, one of the most important days in his client's life. He came to the realization that he could set the mood of the entire reception through his choice and timing of the music he played. A sense of classic elegance, playfulness, trendy pop culture or a flavor of romance would hinge on his choices.

At one point, James had created a demo CD of his own electronic music. Indeed, hundreds of thousands of such CDs are created by tens of thousands of musicians all over the world. He mailed his tapes out to key people in the music industry, hoping that he would hear a quick response which would propel his journey. His CD was distributed and after no definite responses, it slipped from his focus. He continued to work as a top wedding DJ, bringing his best energy to putting together great events. Then he got a surprise phone call.

His music had ended up in the hands of two soundtrack producers. They responded well to his samples and he was asked to work for a healthy starting wage to create some themes for an upcoming animated television program. James had just completed setting up his back bedroom as a home recording studio that would allow him to respond to this offer and begin scoring episodes. The skill that he had nurtured for years- the ability to match events with mood and music- was now in play on a new level.

Looking back, he had been preparing himself for this work, even before it revealed itself to him.

The evening of the show's network television's live debut, James invited a house-full of his closest friends and family to celebrate and watch. The genuine excitement they had for him was made even greater by the realization that they were watching an artist rise to a fresh challenge while growing to create a new definition of success in his life. James' music played a decisive role in the mood and pacing of the program. The animated show caught on quickly, becoming an international cult favorite spawning vast commercial merchandising and media

attention. The project gave James wonderful opportunities
to understand how the music and entertainment industry
worked, while week after week each episode brought him
new opportunities to shine as a composer for an international
television show.

Within his mind and heart, his next dream and desire was to
some day work as composer on a feature length movie score. "I
really wanted to be a film composer," he explains.
"I wanted to take on a really high profile project."
James had just purchased a new home, constructed a new state
of the art sound studio, and had a new baby in the family. The
good fortune mounted faster and faster for him. His attitude,
energy and dedicated work ethics were inspiring.

In the midst of his happiness, an unforeseen dark cloud seemed
to threaten his career and success. Through the deliberate
actions of some associates, his connection to the money-making
project was about to come to an unceremoniously abrupt end.
Other composers had wrestled away the contract.

This was a key moment where he could have been paralyzed by
fear. Instead, in an act of faith and defiance, he went out and
purchased a brand new red convertible.

Friends were a bit in awe to hear how its purchase was made
with such an attitude of disregard for the grim scenario that was
being presented. It seemed to symbolize James' utter belief that
events would somehow evolve to his advantage. Viewed this
way, it wasn't a reckless move. It was beautifully confident. It
was a celebration of abundance and gratitude. It was as if this
gesture by him sent a message to the whole universe which said

"I have faith that everything will work out to my favor." He waited to see the true outcome.

Within days he learned that the contract negotiations had in fact turned towards his advantage. Various personalities who had appeared to be thwarting him were swiftly bypassed by other supportive people with a wiser comprehension of James' talents, as well as the larger role that James could play for the network. Not only did the shows creators demand that James be brought back onto the project, but through new opportunities, he was able to illustrate to the studio the value of his talents as a composer. He received his first offer to score a film. This quickly opened the door to many other movie and television scores.

One of his life dreams, to compose music for films, was made real and enhanced magically the day James heard his first feature score performed by a full 80 piece orchestra at paramount Studios Stage M. Ever excited to share the experience, he had invited a few of his friends to join him in the darkened control room to observe the process and hear his score come to life through the incredible sound monitor system. The studio was filled with dynamic energy. James himself was confident, passionate and connected, as were the recording engineers and the films director. James felt as if he had been doing this his whole life, and that this was what he was meant to do.

Another figure sat transfixed in the darkness of the studio, listening to the string and brass sections rise to the dynamic play of the timpani. It was the woman who had raised James

and helped send him to music school in his youth. James' Grandmother sat silent, enjoying the music.

"This was kind of a gift to her from me," he explained later. "My dream wasn't just to be successful at what I did, but to be able to share this with her, to show her that her belief in me really meant something. It always helped drive me. It helped me to achieve this."

James remains a highly successful award-winning composer. Expanding his scope as an artist seems to be his greatest specialty, and he always approaches new challenges with bold faith. It is a faith in his self...and in something else. Something beyond.

 *"Without passion, all the skill in the world
won't lift you above craft. Without skill,
all the passion in the world will leave you
eager but floundering.
Combining the two is the essence
of the creative life."*
—Twyla Tharp, Dancer and Choreographer

Passion

What drives you as an artist? What's your passion? What fascinates you?

Positive emotional dedication is a key ingredient if you are to fulfill your calling as a creator. The emotions of passion are your greatest indicator that you are headed towards your success, and your true power. When we think again of these artistic archetypes of success, we find real, concrete examples of creative people focusing on the passions to lead them to their greatest, sustaining work.

Some visual artists crave travel. Romantic painter Eugene Delacroix found his voice only when he left the gray climate of Paris, to paint in the distant Muslim world of Tangiers. He was awakened to the color and cultures of Morocco, and spent his life recreating memories of his fantastic adventures amidst wild desert horsemen and sensual harems.
Then there is Andrew Wyeth, whose greatest inspiration came from his next door neighbors. He spent over thirty years painting the barns, fields and inhabitants of the Kuerner farm in Chadds Ford Pennsylvania, his home town.

What of personal experience? No one could depict the ballet in art like Edgar Degas. Yet, it is said that only once did he actually visit the opera backstage for inspiration. His famous pastels were created in his studio, from memory, or were drawn from studio models posing in borrowed tutus. His true challenge came

when his eyesight was failing, and, unable to see the colors of his paint, he turned to sculpting his dancers. By feeling the wet clay, Degas could continue on as a great artist.

What of the limitations of illness? Even though he was deaf and exiled from his home country of Spain, Francisco Goya created his powerful "Black Paintings" on the walls of his own dining room .Nightmarish and vital, they point the way to Modern art. They were carefully removed and now hang in Madrid's Prado Museum.

Claude Monet's almost total blindness never stopped him from painting in his garden. In fact, his resulting overly-bright colors, which he had to exaggerate in order to even see, influenced the next generation of young painters: Mattisse and the"Fauves". (How ironic that a wild youth movement in painting was actually influenced by visual degeneration brought on by old-age!)

How do we "find our voice"? Remember that direct actions can cause a solution to manifest. Georgia O'Keefe rented a room in New York for a week. She locked herself inside along with all of her paintings, and vowed only to leave when she came to the decision of "what to paint". While capable of doing almost anything, she decided upon vivid close-ups of forms suggesting nature. She focused in and her work through that focus, became famous.

Faith Ringgold was influenced by being around fabrics at home with her mother, who was a designer. Faith began employing bits of fabric and quilts in her art, which she combined with painting and story-telling. By exploring these traditional elements, she developed a warm, intimate style.

Winslow Homer started as a successful big-city commercial illustrator. His heart was in nature. He abandoned his safe career to live along the rugged northeast coast. He redefined the rules

and applications of watercolor, while painting powerful scenes of man confronting the turbulent sea.

What of rejection? French Sculptor August Rodin was commissioned by Directorate of Fine Arts to create a simple set of bronze doors for a new museum. He went way overboard, encrusting the frame of the portal with dozens of tortured nude figures until the doors wouldn't even close! The Directorate rejected the results. Rodin cancelled the commission, keeping the doors for himself and turning them into his masterpiece: The Gates of Hell. He worked on the "Gates" for the next thirty seven years. From the figures in the design came ideas and models for many of his other future sculptures.

Should projects always be expanded into grand statements? The great Spanish painter Diego Velazquez developed a technique of seeing which affected not only his brushstrokes but also his subject matter as well. He was able to recognize the quiet dignity that resides in people, apart from the physical body they had been born into. He painted portraits of the deformed dwarves and jesters at the royal court of Madrid which show the same attention and care given to formal portraits of King Phillip. Possibly they are some of the most sensitively unsentimental portraits in existence. When invited to paint Pope Innocent X, the living embodiment of the Catholic Church, the artist chose not to include billowing drapery, heavenly light beams and accompanying angels as most painters habitually did at the time. Without resorting to superficial flattery or over-blown designs, Velasquez instead painted the Pope as he really appeared: a slightly impatient man, wearing a costume and perched stiffly in a gold chair. The jitteriness of the Pope's cronies was made apparent when they saw Velazquez completing the portrait. They told him that they feared the painter had not shown the Pope regally and majestically enough. When the painting was finally unveiled however, the Pope was said to have silently examined his depicted image before uttering the words "Troppo Vero"- "Too true..."

He then paid the painter with a gold chain and medallion.

Passion is the inner-drive that propels us, that can sustain our heart-pounding inspiration through years and decades. What, in your own heart, is calling you? How do you focus in on that which will set you free? What is your true voice? How will you grow to become capable of using it in order to become your greatest self?

In Hindu Art, there are many striking images depicting Ganesh, who is a deity with a round human body but with the oversized head of an elephant. Ganesh is revered as the deity who overcomes obstacles, and he is often shown accompanied by a little mouse, or a shrew.

This little creature is Ganesh's vehicle. The mouse symbolizes how stealthily and effortlessly the deity is able to maneuver. It is implied that just as a mouse can get through small spaces and zip to its destination, so can Ganesh. He is completed by these advantageous qualities, even though he is large and cumbersome.

In a real way, art is your vehicle. Art symbolizes the enhanced qualities that you yourself require to accomplish your calling in life.

Do you think that you became an artist just so that you could have a job? Do you believe that you are practicing your techniques just so you can "get better"? Do you honestly think that art is in your life simply because it brings you enjoyment? Your art is bigger than you think. It is through your art that you are meant to accomplish something greater.

Passion

 "Music expresses that which cannot be put into words, and cannot remain silent."
—*Victor Hugo, Novelist*

The New Song

Michael Giammatteo never kept a written journal.
Instead, he wrote songs.
He wrote a song while his wife was pregnant with their first child and when their son Vico was finally born, he wrote a song to commemorate the birth.

Michael had been writing songs as a kind of ongoing personal response to meaningful events in life since he was a teen. So it was not a surprise when he also wrote a song the day Vico was diagnosed with autism.

A song writer documents the human experience from many viewpoints but this was one in Michael's life that was painfully new. It was a natural way to get his feelings out after such a life changing day. He recorded that song the weekend of the diagnosis, and put it away, never even listening to it.

Can anything capture the emotion of a moment like the combination of music and words are able to? Around the globe, music is embraced for the role it plays in entertainment, as traditional ceremony and as art. Music is the backbone of our popular culture. Thousands of clubs in cities all over the world are filled with live music each night as orchestras, bands and soloists perform every conceivable combination of sound. Music is public. Yet Michael's new songs were now about a very private world.

They continued to be written to reflect his questions and insights throughout the first year of Vico's diagnosis, which Michael remembers now as the worst year of his life. At the time, Vico was three. He was non-verbal, made no eye contact and avoided people. Doctors predicted that he would never get any better than he was.

After bio-medical and traditional therapies began and Vico started to improve, Michael's new songs reflected his expanding relationship to his son, the ongoing strength of his marriage, and real hope. What came from all of this changed Michael's comprehension of music as a form of communication, literally.

When his son was beginning speech therapy, he was three years old and was almost completely non-verbal at the time, having lost all language. Over the months, his speech pathologist was patiently coaxing single words out of him, ("juice.") Then two word phrases, ("Juice Please.") and even the beginnings of three word phrases, ("More juice please"). Knowing Michael was a musician, she expressed her frustration about commercial children's CDs that were useless to her practice, as the singing was too rapid for children with speech delay to understand. She asked if he could record some children's songs, making sure the singing was at a slower tempo. Michael and his songwriting partner David Wholihan were intrigued with her request, and they set out to experiment with the idea of creating songs which could be used to help speech delayed children comprehend language. The first versions were created at a very slow tempo. Michael's son responded well to the music, and even attempted to sing along, using limited vowel sounds. This was very encouraging and although they were pleased with the results, they admitted that the songs were so slow as to be unmusical, and difficult for adults to listen to. In order to address this, they decided to record the songs at a regular tempo with a lively beat, but keep the vocals slowed for the benefit of the speech-learners. Understanding that he was going to ultimately be stuck in the family mini-van listening to

the recordings, they rearranged the children's songs in a rock style that he and other adults might actually enjoy. They added pounding drums, heavy guitar and pumping bass.
Michael had brought the joy back into the results. "I never understood why little children's CDs were so watered down," he says. "Kids love rock music!"

They recorded six songs like this, with Vico engaged by them all, singing, dancing and clapping along. In an exciting breakthrough, Michael was now able to share his love for music with his son...in a form that was meaningful on so many new levels.

Michael shared copies of his songs with a few other parents at an autism support group meeting. The parents all had children challenged with language development and the feedback he received was fantastic. One parent reported that her son was clapping to "Bingo", and that it was the first time he had responded to music not associated with video. Another shared that her child shouted "pop" during "Pop goes the weasel." Again, it was the first time he had ever attempted to sing along with a recording. For these children, the specially arranged songs became a catalyst to open the possibilities in speech development. The music was fun as well, recorded in a style to cause parents to smile and laugh along the way. It brought a levity and joy.

The word spread and parents began asking where they could purchase the "TeamVico" CD. The two musicians began selling it for a few dollars, to cover the cost of materials and postage. They continued recording and soon had enough specialized children's recordings to fill a full length play list.
The cost of treating the effects of autism is expensive, however, and Michael did not have the funds to meet the new demands of distributing his songs.

An organization dedicated to music for healing called "Angeles on Earth" heard about what Michael was doing and helped to cover the cost of pressing a run of CDs. TeamVico became a "real" band. They performed for children at fundraisers for CAN (Cure Autism Now), ARI (Autism Research Institute) and TACA (Talk About Curing Autism).
The first TeamVico CD was named "Independent Children's Album of the Year" at the Los Angeles Music Awards.

This is the way that our calling can manifest.
We are instilled with an attraction to our art, and we may not at all be able to envision how our art will ultimately serve us and serve others. How could we? In the beginning we are excited to learn art, to play with it. Over time our art creates bridges in our lives. Our art becomes a tool for understanding. Our art becomes our vehicle for growth and transformation. Our art begins to take on greater nuance and flourishes with more personal power than we ever bargained for...if we answer when it calls.

Michael's own, deeply personal original songs became the basis for TeamVico's third CD, a concept album telling the story of his families experience with autism. Michael and his wife Moira have become respected speakers in the growing community of families affected by autism. Moira promotes effective options for the treatment of autism, while Michael speaks on ways to strengthen family. In this way, their ability to communicate and provide support for others expands continually.

Vico has grown and is now completely verbal.
"Not only is he very social," says Michael, "he even has a wicked sense of humor. We were led to believe that, at three years old, he would never get any better. At that time he avoided people, made no eye contact and would not speak. Now my son does the impossible on a daily basis, so each and every day is a miracle."

The New Song

 *"The hidden harmony
is better than the obvious."*
-Pablo Piccasso, Artist

Hidden

I had entered a treasure-trove. It was a tantalizing discovery, hidden from view from the rest of the world. My jaw dropped in disbelief...

"Take what you like, young man," said the sweet little old lady who stood by my side, garage door clicker in hand. She was a neighbor and had invited me to her home in our sleepy suburban neighborhood because she had, in her words, "a few art-supplies to give away,"

So here I stood, in her garage, which was filled with what appeared to be literally thousands of paintings, stacked tightly in bundles from floor to ceiling.

"These were my husband's paintings", she explained." Maybe you could paint over them and re-use them."

"What? You are saying I could paint over them?" I asked in horror. "What are you saying? Don't you want your husband's paintings?" The sweet old lady shrugged and shook her head, in a sad, quiet way. "What can I do with these now?" She responded. "What you don't take today, the trash people will be clearing out tomorrow..."

To me, this was an artist's nightmare: Imagine passing away and your spouse tosses your art out in the garbage. How could she do this? I asked if she had children or other family members who would be interested in saving some of the paintings. " No", she assured me. No children. No family.

I had to see some of these paintings. I began to un stack them right in the driveway, and was overwhelmed by the color and activity of the canvases. They were abstracts, fantastic designs, geometric explosions of a passionate nature.

"My Howard was a door-to-door vacuum-cleaner salesman," she said. "He worked all day, and came home to enjoy dinner. After that he would spend some quality time with me before heading out here to the garage. He kept his paintings a secret for awhile but he couldn't hide them from me forever." She eyed the contents of the paintings with disinterest. I was listening as I tried counting the canvases in the stacks. There were maybe three thousand of various sizes, and every one thickly painted.

"I can't paint over these," I told her. They are too thick. They would crack. But they are your husband's art. Why don't you at least pick out a few to hang in the house to remember him by?" Again, the sweet lady seemed untroubled. "He was self-taught," she continued. I suppose you could say it was his hobby."

But the canvases were amazing to me. Bold, confident compositions and experiments of every sort passed before my eyes as I carefully flipped past a life-time of creations. This was not just the work of a vacuum-cleaner salesman hobbyist. This man had been a real artist. He had been a dedicated, driven artist who had invested decades of sweat and blood into his work.

The sweet old lady went inside to make me a sandwich as I poured over the paintings. This man had led a double life: Mild-mannered vacuum-cleaner salesman by day and expressive painter by night. I looked and noticed how each artwork had been carefully dated on the back. The earliest seemed to have been made in 1955 and the last were done in 2006, just before he went into hospice care, after his stroke. ...and it was about to be thrown away. Didn't his wife give damn?

Didn't she care at all?

She came out with a cheese sandwich and some lemonade. "I'm sorry you can't use these to paint over," she said. "The trash service will be here tomorrow and-"

"Listen, why don't you please pick one out to save?" I blurted. "He spent over fifty years making these. I think it would be so nice if you saved just one."

The old lady's eyes widened and she chuckled gently. "Young man, do you think that I don't understand my husband's joy for making art? Please come inside for a moment."

I followed her into her front door, and expected to be met with fussy old-widow décor.

But what I saw blew me away.

Quilts. Every wall was covered with brilliantly colored, unbelievably cool quilts of every size. All of the quilts appeared to have a bold, vibrant style of design that looked like...her late husband's paintings!

"You see," she said, "My husbands paintings inspired me to become somewhat of an artist myself. That was his greatest gift to me. He helped me to understand color, shape and pattern. It started off as a hobby, but the last forty years, we have been collaborating on these together. Howard created the designs, and I transformed them into quilts."
She took me on a tour of the house, pointing out every quilt, carefully describing the painting of her husband's which had inspired each one. Finally we reached a prominent wall in the study that was entirely empty.

"My favorite Quilt used to hang here, for over twenty years." It was the biggest, the finest quilt we ever collaborated on. I wrapped my Howard in it when he passed away. He was buried with it. I shall leave the wall blank now. I will never fill it."

I finished my sandwich and gave her a kiss on the cheek, thanking her.

That day changed my understanding of art...and love.

She went into the kitchen to do the dishes. Before leaving, I snuck back to the garage and brought in a single painting. It had been tucked among the stacks- a portrait he had done of her, dated from forty years earlier.
I placed it on the mantle.

Hidden

 "A good traveler has no fixed plans-
and is not intent on arriving.
A good artist lets their intuition
take them wherever it wants to..."
Lao-Tzu, The Book of the Tao

The Traveler

Soft voices arose through the air.

A group of young Buddhist nuns in Vietnam had encountered a traveling American artist named Robin Rector-Krupp along with fellow members of a Grand Circle tour group. The barriers of their cultures, their personal and national histories and their linguistic differences all dissolved when they spontaneously took turns singing. First the Americans asked the nuns to sing. The nuns declined. They were too shy. So the tourists sang their rendition of "America the Beautiful." Experienced this way, the words and music took on a new air of celebration and discovery. The nuns gathered their courage and offered their own song in unison. The sound was soft and melancholy as they sang of the coming signs of autumn. Each group stood silently as the other lifted their voices in song. Each group allowed themselves to pause and focus within the moment, to exchange the vocal message of trust and joy.

For Robin Rector Krupp, this exchange of songs served as one of the many lasting sensual memories that have fed her creative message to the world.

The aural stimulation of the exchange with the nuns would have been impossible in a previous decade, when war had ripped Vietnam in half and anthems came with charged political meaning. Yet a war needn't have been required to eliminate the experience. Robin might have eliminated the option from her own life, by deciding not to travel to Asia. She might have remained perched in front of her easel, at home.

Courage is often the manifestation of stepping outside of our comfortable patterns. Sometimes it requires us to leave our first and most convenient solution behind us. It might require that we leave the comfort of our home. Many of us envision our lives unfolding predictably within the limits of our expectations, or the expectations of others. How many of us hold in reserve the possibility of contingency that the characters in our lives could change, or that the ways we express our thoughts and emotions might transform?

As creative people, many of us share a secret among our selves. We sensed that we were "different" in some way, perhaps when we were quite young. We were pulled to engage in pursuits that diverted us from the day to day reality that seemed to swallow so many of our peers. Ask yourself: When did you notice it? On rainy days, did you relish the activity of drawing when all the kickball courts were flooded? Could you have easily explained this joy to anyone? As a child did you spend hours watching your reflection in your bedroom mirror as your physical body moved to the beat of recordings played over and over? These dances may have been for imaginary audiences but were really for you, were they not? As a musician, when did you notice that your music began to come not from your instrument, but from within you? When did you recognize your inner voice that compelled you to create poetry? When did you begin to believe that you could sing?

As we grow older beyond childhood our circumstances are variable. Some of us find friends who share or support our compulsions. Some of us go on to a school that promotes the development of our skills. We might pursue a professional career in our field. We might come to teach our craft to others. We might engage in our artistic passion on a personal scale, purely for love. We may even cease over time to hold that passion, or to act upon it's calling. We might let our artistic voice fall fast asleep, like a beautiful car, silently rusting in a field of poppies.

Still, in all of these life situations, creative people continue to feel that they are members of a charmed subculture. After all, we are artists in our hearts. Other people are caught in the rat race of reality. Other people have their eyes clouded over by conformity, regiment, and dull grayness. "Not us!" we protest. "We are the poets. We know better than to be lulled into contentment by the plainness of society."

In truth, we are not immune to this grayness. We are not beyond the dangers of losing faith and emotional drive. We are all capable of stagnation. Many of us find peace in clinging to a place of safety, where movement is kept to a minimum, and action is taken only when survival is at stake.

If there is a power we have that is truly magical, it may be that we are hungry for the sensation of discovery. We are capable of being able to kick-start our lives back into motion easier because the act of creating is familiar within us. When old habits are bypassed, the seed of renewal and exploration causes us to jolt back to life. Creative people are special because we feed upon this jolt, whether we fear it or crave it.

When this jolt of rejuvenation begins and the flow of life reinvents the tired day-to-day pattern with vital bursts of energy, art can churn from the core of our being, welling up like freshly charged spring. In such a new incarnation, the medium of creation may shift. The artist seeks to master new tools, more appropriate languages and greater insight about humanity.

Long before Robin Rector Krupp stood singing with the Buddhist nuns in Vietnam, she was growing up in America, drawing.

"I always drew" Robin laughs, remembering her childhood.
" My mother told me that by the time I was two years old, if I was not supplied with paper I would just pull up my skirt and

draw on my thigh." Now, at 60, she tells how that girl grew up to share her art with people around the globe.

"My mother was a playwright and my father was a mathematician. I decided to be something different, a visual artist. I went to art school, got my master's degree, and had exhibitions. Everything seemed to be unfolding just as an artist's life would be expected to.

"There was an exclusivity to it all, but it didn't make me feel complete. Staying in the gallery scene was just not as appealing as doing something... else."

What else? She did not need to search hard to find the next aspect of her creative output: Writing began to creep into her life. A painter friend who was about to publish her first book gave Robin the inspiration to go back to school and study children's book illustration. Robin's journals and poems now turned into stories. She was thirty when it became a part of her regular routine and she became a visual artist who also wrote. Three years of rejection letters from publishers only challenged her to not give up. The thrill of newness motivated her to continue along her evolving path.

At the time, she was married to E. C. Krupp, a scientist, and this played a beautiful role in how the integration unfolded.

They decided to make a book for children together, which would incorporate his text and her illustrations. It was called The Comet and You, which was followed up by The Big Dipper and You, and The moon and You. All titles were designed to introduce young readers to heavenly objects while filling them with a joyful sense of discovery. Robin wrote and illustrated three more books including the award winning Let's Go Traveling. The book world brought with it many challenges and rewards which caused Robyn to grow in exciting new ways. Incorporating all of her skills, she has presented assemblies to

over 300,000 children over twenty years and has devoted time to help rural schools in South Africa. She is still growing, still traveling, and still continuing to become her true self.

Her story highlights a vital aspect of the path to fulfillment as an artist: it involves the transformation from one kind of person into another. It requires change. It demands that we take on a new medium or a new way of creating our work. Of course, change is the greatest challenge most of us face because it demands the greatest actions. We can change within ourselves, and we can change beyond ourselves. One of the most meaningful commitments an artist can make is to evolve from being an isolated entity, into a bringer of change in the lives of others.

 "The task of art is enormous...
Art should cause violence to be set aside.
And it is only art that can accomplish this".
-Leo Tolstoy, Writer

Light in The Cage

Who is worthy of receiving your gift?

When you are ready to reach out to connect with and compel others, who will you share your art with? Who will you meet?

Artist Jill Ansell made a choice to meet people who hold the lowest grace in the tribe. Many had actually been removed from the tribe itself, due to their mistakes, ignorance or wrong choices. Is this where an artist belongs?

Jill's own artwork reflects an admiration for the devotional art of the Buddhist traditions.. Animals inhabit idealized landscapes bursting with dreamy color. The work she creates for herself exhibits charm, delicate detail and joy. Yet, leaving the safety of her studio she brings her art and her artistic powers to fellow beings incarcerated in the California state prison system.

"If I thought about their crimes, I could not have gone in," Jill says of her residencies. "I always embraced compassion as an idea, but compassion without judgment was my real challenge."

Her early life as a teacher of art sprang naturally from her life as a painter. She taught in the beginning as a way to help pay the bills. Jill quickly became drawn on a spiritual level to the act of sharing; making an impact and watching others grow from the interaction. She worked with at-risk children in Los Angeles, and became a witness to the reality that art had an affect on the behavior and the state of happiness in her student's lives. Decades of arguments over the questioned impact art has upon

student's well-being and educational development are hollow to the ears of those educators who have seen with their own eyes the positive benefits, and Jill knew this truth as well.
A life can be changed through art...

When we focus upon a new direction or become open to the expansion of ourselves, doors begin to open. In the pursuit of further career enhancement and art experience, Jill submitted a grant proposal which would alter her life. She wished to create a mural, and she required a site sanctioned for such an undertaking. The site was a county jail.

"It just came together that way," she says. "Of course, the thing that reverberated through the project was my proximity to the inmates. I was suddenly in contact with a whole class of people who were real criminals, many of whom had few positive opportunities and grew up in a poverty I had never known in my own life. The mural project was successful and led me to apply for a further grant to teach art on a regular basis within a county prison." Far from a comforting studio or school room, Jill became part of the rhythm behind bars, with her art workshops being a scheduled break from the monotony and bleakness of the inmates' existence. Jill describes the journey:

"I held painting classes and my original intent was to work only with the experienced inmate artists, but as the project developed it became clear that those who would dedicate themselves were not only those with experience, but those who wanted to learn from scratch. It was difficult to keep a consistent class, as prison life by nature has severe limitations such as lockdowns and other incidents that impede class progress. Perseverance amidst these limitations resulted in a very productive year."

Teaching art to anyone can be a process where the students, particularly adult students, bring with them a variety of baggage, including self-doubt and fear. Jill found that the

participants were no different. As they collectively created a wide variety of subject matter, the process of growth became evident to them.

"Some wanted to quit along the way, but when urged, pushed through their creative blocks which resulted in a sense of pride and self-esteem. Despite a lifetime of work as an artist, I never cease to be amazed at the healing power of artistic expression. In an environment that often spawns depression, acrimony and hopelessness; I found jewels of imaginative imagery, color, expression and hope. People of diverse backgrounds were able to work side by side in harmony, a situation which is often difficult in the prison milieu."

While cultivating these results, Jill also walked into a place of danger, both spiritually and physically. Artists who transform this way must be aware that the proximity and empathy towards those they inspire can draw them into the same energies of chaos and despair unless they practice an amount of distancing and focusing solely upon delivering the greater message of empowerment. On a few occasions, she was also threatened and intimidated by inmates. As a woman in a male inmate crowd her safety had to remain a priority.

Is art designed to "save" others? Is an artist to be assigned the role of friendly ambassador in order to reach Valhalla? They are most certainly not. Jill knew enough to realize that on the surface, her role was to entertain the inmates, or perhaps empower them . In truth, more importantly her aim was to sensitize her students.

Sensitize them? To what?

Learning about Jill's admiration and care for these participants at the prison is likely to offend and even enrage some of us. She is speaking of men who stole, assaulted, raped and even murdered others. They left behind victims who might rightfully

feel angered at the prospect of these wrong-doers being allowed to participate in the enjoyable privilege of art-making.

"Every human being has potential to be in an extremely dark place," says Jill." These people had made terrible choices, terrible mistakes. My aim was not to judge and them and not to reward them. I wanted them to become sensitive, so that they could better understand the human part of themselves. In doing so, I wanted them to better sense what they had done to the lives of others. Lecturing them, and even imprisoning them couldn't do that. They had to learn how to actually feel it. I wanted them to feel. I wanted to teach them to feel for their victims."

In small ways, artist-inmates did express to Jill a more sensitive understanding about the life they were now leading. Participants were brought closer into contact with the part of them that had a conscience, a heart. Her project functioned for some like a mirror, held up so that the inmates could sense something important within themselves.

The resulting artwork of Jill's Prison class sessions filled the walls at Los Angeles' A Shenere Velt Gallery, part of The Workman's Circle, a jewish social action and cultural organization. The in-mates also created the frames and cut the display mats, though none of them would be free to see the actual exhibition. The art would speak for itself. It was the eyes of the gallery visitors who would view the work and attempt to put the pieces together from their own perspective.

Compassion without judgment is Jill's challenge. But this challenge was not solely restricted to the hours spent teaching art in the prison. She has her own personal experience of loss, which entered into her life and altered her awareness. Jill's own husband had been a victim of a crime that took his life. A tainted blood transfusion procedure in which treatments were compromised had led to her husbands death, not from

an attacker in a police line-up, but at the hands of anonymous corporate decision makers. As a surviving wife, she herself had to learn to forgive.

"I had to find a way not just to escape my sadness. I actually had to face my sadness. I had to find peace within me, or I felt that I would be destroyed by rage. I turned to art. I deliberately focused on painting my own personal images. My paintings became metaphors for the soul's ability to forgive, even through environmental devastation. I believe that the potential for darkness can be overcome. We can all heal. I am proof. Through my bodies of work, through that experience, painting saved my life."

Themes of crime, compassion, the plight of victims, the survivor's forgiveness of the perpetrator's ignorance all play together in her experience. Alone, Jill used art to strengthen herself. Venturing out into the world, she brought that strength into play by connecting to others, both at the prison and the gallery. It is this sweeping connection, this relativity to a larger purpose, which bears the mark of a higher spiritual path.

Being alone in our studios is where so much of our power is born. It is where we find our grounding. The isolation is intoxicating for us, isn't it? Artists are often afraid to leave its shelter, but find over time that they may always return to it, to rejuvenate and rediscover. When we leave the comfort of our own isolation to connect with and compel others, we will begin to shed our sense of aloneness.

Count on it: your new journey, your new calling will involve connecting with other people. They will come in all shapes and guises. They may come from all educational levels. They may seem friendly or they may seem indifferent. Some artists plead the case that they "are not good with people." Yet most of these creative individuals carry on quite well when they need to. Many proclaim that they "are not good at speaking." Yet many

of them are capable of direct, poetic observations about the subject that they love the most: art.

It is your great job to bring that love to your conversations, however tangibly or indefinably that love may be returned. Listen. Every person you meet can be your teacher.

Light in The Cage

 "Knowledge is like a garden:
if it is not cultivated, it cannot be harvested"
-African proverb

The Myth of Age- Hans Burkhardt

A little white-haired man, probably in his eighties, shuffled up to me and my friends on the first day of art school. He pulled a cart on squeaky wheels behind him and he grinned while his eyes sparkled in the dim florescent hallway lighting. My friends and I were raucously chatting about what we had done during the summer vacation. We were all about nineteen years old then, and had no idea who this elderly gentleman was.

He just stood beyond our circle and smiled, politely listening to our party exploits and tales of teenaged recreation until there was a momentary lull in the conversation.

Then, in a thick Swiss accent he unexpectedly spoke: "Look what I did this summer while you were all at the beach."

From his cart, he pulled out a thick portfolio of colorful pastel drawings. Then another portfolio and another. He handed one to each of us and shared literally hundreds of artworks. All were dated from the last three months. The loud youthful blabbering from our mouths came to an abrupt end. As we perused the bulging portfolios, a silent realization crept over all of us that we were being challenged by this cuddly little man. He was reminding us that artists make art. When it was time for our drawing class to start, we all filed into the classroom. The old man wheeled his cart in last, and he set up in the back. We learned that he was in fact our instructor, Professor Hans Burkhardt.

We still didn't know who Mr. Burkhardt was, though. We didn't know that he was a prominent figure in art history or that he and the famed painter William De Kooning had both been friends and shared studios with the older Arshile Gorky, the famed creator of abstract expressionism. We were not yet familiar with Hans' powerful anti-war paintings or huge accomplishments in the art world. At that moment he was someone who had bested us. He was someone who had shown us a taste of quality we had been unfamiliar with. As we grew to know him, it was first and foremost his amazing output of work that had the biggest impact on us.

For every one of our drawings, he did fifty. Whenever we used an exciting color in our work, he used it better and more freely. When we were too casual he would implore us to become serious. When we grew too serious, he would laugh merrily in our faces! While he created his pastel drawings in the back of the room, he turned art making into a kind of play-time. But for me and my group of friends, we sensed the importance of why we were there. We soon found ourselves setting up right on the floor, sitting directly under the figure models, as if being that close to our subjects would help demonstrate to Hans our sincerity and commitment. Two full semesters passed. At the end of the school year, he waved good-bye to us and called out sweetly, "Have a nice time at the beach, boys and girls. See you next year. I bet you will all have nice tans!" It was his way of challenging us to a sort of duel.

It worked. How did we spend that summer?
We drew. And drew.

We started by going to a local mortuary which featured exact marble replicas of Michelangelo's "Pieta", "Medici Tombs" and "David". We spent hours there happily doing studies in charcoal (remembering to look appropriately solemn whenever a funeral party passed by). We went to the zoo to draw the animals, attracting crowds of onlookers. We went to museums

to draw from the master paintings. We attended figure workshops and then we took turns posing for each other until late in the evening. When we did go to the beach...we took our sketchbooks and drew the angled rock cliffs, the swirling waves, the translucent clumps of seaweed and the hovering seagulls. We explored the world that summer with a new sense of urgency and vigor.

Fall finally arrived and when we saw Hans Burkhardt in September, we anxiously showed him our work. We had our own portfolios now, bulging with drawings. He quietly smiled while he viewed our creations and then began the class without a further word. Things were different, though. We were different. We were stronger, looser. More bold, more confident, more playful. In a way, that summer was the beginning of my life as an artist. I keep it with me. After Hans died I viewed a retrospective of his work at the elegant Jack Rutberg Gallery in Los Angeles. Hans had created vast series of works depicting the horrors of war, including his masterpiece called: "My Lai", a protest against a massacre of civilians in a Vietnamese village. The wall sized canvas includes actual human skulls affixed to the surface. Hans had also created the most care-free pastels I have ever seen. His outpouring was amazing. I will always remember this "little old man" kicking me into action. He never chit-chatted. Every sentence was provocative. He did not need to preach or lecture. As I myself grow older I realize ever more clearly that his words, his little jokes, were disguised calls for passion, always drizzled with love.

 "All the flowers of all the tomorrows
are in the seeds of today."
—*Indian proverb*

The Heightened Experience

Art enhances us. The sensitivity we use in our art making can spill over into the whole of our lives. We may discover that art is not confined to our canvases, our cameras, digital monitors and tablets, or time spent rehearsing and performing. Art can manifest in our "normal" times. When this happens, our "normal" times can become poetic, profound and soothing. This awareness will cause us to rise up to greater heights. Or more magically, this awareness puts us into contact with day-to-day experiences that we have taken for granted.

To perceive this heightened experience is the ultimate goal of artists. It is also the ultimate thirst of their audience. Any style of art we can imagine, from any epoch, is rooted in the pursuit and communication of this goal. Whether used as a tool for self-expression, decoration, propaganda, commercialism or entertainment, the creator and the receiver are both impacted by this state.

Digital photographer Mike Shaw from the U.K. describes his first relationship with art and the quiet moment that changed the way he saw the world around him:

"I have always had a love of art but had a problem expressing it because I never had the patience. I spent a long time feeling that I was in the wilderness. I simply went to work to pay the bills to keep my family safe and warm. Then I picked a camera up and thought it was worth a try. I went through the process I normally do with something new, which is throw away the

instruction book and fiddle until I get something I like. Soon I upgraded my equipment thinking I would upgrade my talent too, but it didn't work.

I was floundering while thinking my photography would go the way of most art I tried."

One sleepless summer night, Mike decided to get up before the dawn. It was around 4:30 am, and the air was damp but he could feel the first warmth of the new day starting to slowly filter through. He packed his camera and decided to go and see what came about.

"I sat in a farmer's field waiting for the sun to emerge enough to give me some decent light. My backside was wet from the dew but I really didn't care. I watched the sun come up and the colors were fantastic. I went to stand and leave when I looked at where I had been sitting. Just in front of me were a few daisies. Nothing special, but the sun was coming up behind them. I sat back down and watched, just looking at these simple little flowers in the light. I was so taken by them I nearly forgot to take a picture. I lay down on the ground, as close down to them as I could, got the picture and then sat there for the rest of the sunrise."

From that point forward, Mike's vision and belief in his photography took hold. He realized that his engagement with the world around him was the fuel for his work.
"Since then I frame my world, I constantly look at things as if I'm looking through a viewfinder. There is beauty every where, people just need to look a little deeper at times."
His digital images of atmospheric landscapes and architectural environments all reflect this sense of wonder, as if both he and the viewer are discovering things for the first time.

This moment of intimacy and focus represents the awakening that, ultimately, every creative individual passes through.

It is the seed from which strength and commitment grow.
The catalyst for the awakening sometimes arrives gently.
Yet, other times it can come as a result of abrupt surprise.
In either case, without the heightened, nuanced experience
gained from art, we face our life's hurtles with a limited
insight and a want for grace.

There is a reason that the great Japanese Samurai, masters of
battle and strength, were also regular participants in the delicate
tea-ceremony, which included elements of poetry and deep
appreciation of artistic aesthetic.

The practice of art is not to "make stuff."

The act of being an artist can produce an inner realization
which, in the midst of coarseness, may be one of the most
beautiful states of enlightenment we can nurture within
ourselves.

 *"Feet, what do I need you
for when I have wings to fly?"*
— *Frida Kahlo, Painter*

No Restrictions

Tommy Hollenstein's paintings are alive with color.

Vibrant reds and rich blues collide with streaks of yellow suggesting veins of energy. Colors like sunsets or lush abstract landscapes radiate seductively. Some canvases are elegantly stark, while others are dense with layers and rhythm. It's the rhythm that is captivating. Evoking movement is the painter's greatest challenge, for the picture is in reality motionless before us. It is the skill and passion of the artist that can cause the surface to appear to dance. Once the viewer is captivated by the overall dance on the canvas, they are lured closer to inspect the individual strokes on the surface. With Tommy's art they will find no brushstrokes at all. There is something else: Patterns laced within patterns and spirals of swirling tire tread-marks. Tommy Hollenstein paints with his wheelchair. Our culture easily embraces the victim, but Tommy has nothing to offer in the victim-hood department. Instead, he concentrates on his powerful strength and gifts. Without a pause he will tell you that his art is about "Joy and passion."

Charismatic and handsome, he does not hesitate to talk about the day when at age twenty five, he broke his spinal column in a bike accident that changed his life forever. On March 10th, 1985 when he flew off his bike and hit the ground, he remembered hearing a "pop" like the striking of a metal rod. Then, he remembered floating up into the clouds.

"I was dead", he says. "I could look down and see my own body laying there motionless. I remember thinking that I was not yet ready to die. I asked God to give me another chance." When Tommy returned to his body, he knew immediately that he

had broken his neck. His buddy called an ambulance, and the seriousness of his injury was confirmed. When he arrived at the hospital a priest gave him his last rights, but Tommy's gratitude for life surpassed his sense of loss, and he fought to live. After six difficult months in rehab, he was able to get movement in his arms and learned how to function as a paraplegic. Tommy would spend his remaining life in a wheelchair.

Of course, being the amazing person that he was, after being discharged he immediately set about living his life to the fullest. Without the use of his legs, he still enjoyed boating and water-skiing. His interest in this dynamic sport led him to even create a special device that paraplegics now use to water-ski. This kind of love for other people ensured that he would always be active and social. To be sure, Tommy was not alone in the world. His ongoing journey was enhanced greatly over the ensuing years by physical therapists, family and friends... and also by a dog named Weaver. Weaver was trained specifically to aid Tommy and grew to become his trusted companion. It was through this special relationship that Tommy was led to realize his powerful voice as an artist.

Tommy speaks with emotion as he relates the idea that opened this door. "I knew that my dog wouldn't always be in good health forever. I wanted to do something to remember Weaver by. Why not record his paw-prints?" He laid a flat board on the ground in his garage and coaxed Weaver to dip his paws in colored house paint. Then, as Tommy rolled along in his wheelchair, Weaver walked faithfully beside him, leaving heart-warming paw prints on the paper. They tried this together a few times, and during the process Tommy accidentally got paint on his wheelchair's tires. He realized that now he was making tracks on the paper as well. Trying to remove the paint from the tires only created more colorful markings. Then it hit him: He was painting.
"I tried experimenting with different colors, and patterns. I found that I had really fine control over the sensitivity of

my marks," he states. Indeed, the built-in computer in his wonderful Invacare motorized wheelchair allows him to maneuver with varying speed, direction and pressure as he paints. He was hooked.

A number of dedicated paraplegic and quadriplegic artists around the world have learned to paint with brushes delicately held by their teeth, or with their toes. Their work is incredible in that it is a testament to unstoppable desire, but it also reflects the common drive that so many artists have within them. Learning or relearning a manual dexterous skill is simply part of the path for many, who will not let their creativity be hindered in any way. There are inspiring stories of the French Impressionist painter Renoir asking assistants to tie paint brushes onto his crippled hands with rope when he could no longer hold them due to arthritis. Old photos attest to that. This was how Renoir, who was also confined to a wheelchair, created his last shimmering paintings.

"I feel free when I am painting in my wheelchair," Tommy says. "I feel no restrictions." Does not relying on his limbs or hands mean that his mind and his heart might perhaps be more readily involved in the creation process? Watching Tommy "glide" over a canvas while making marks with his wheels gives the impression that he is "flying" above his art. He leaves his tracks in paint, announcing without irony or self-pity that he is actually dancing.

Tommy Hollenstein's first dog Weaver has passed on. His new dog Hiley now attends his crowded art exhibitions with him. Growing acknowledgment by the media helps get his paintings out in the public consciousness. His art projects with children help him spread the message of strength. "Do what you love. Have gratitude for life," he says. Tommy was dealt a card that would challenge all of us. He responded to that card with bravery and a new vision of who he was.

 "When you do things from your soul,
you feel a river moving in you, a joy."
-*Rumi, Poet*

The Dance of Survival

Forest Franken is a muse. She is an inspirer.

The art of dance is immediate, primary and seemingly in-born. Smiling babies rock in joyous outbursts to music. School children boldly perform in follies to packed auditoriums of parents with video cameras who swoon at their every step. Teenagers test their newfound bodies when they move in ritualized mad-dashes to maturity. Adults come to embrace the tribal tradition of dancing like characters in old movies, at ceremonies and social events. They go about fulfilling their duties out of nostalgia, respect and even heartfelt revitalization. As life unfolds, many of us grow to forget the immediacy of dance. We may become lethargic and grow fatigued. Our flesh imprisons us until illness; either apparent or invisible ultimately withers our bodies. We forget the dance.

And then there are those of us who do not forget- some who maintain this intense relationship with their bodies at all time, under every circumstance.

Forest says; "Movement as an art form, as a spiritual practice and as a therapeutic modality has been river-like, running through the course of my life." Forest calls her relationship to dance "the first opening to the river." It occurred in childhood, through spontaneous dance.

"When I danced," she remembers, "I named the truth without having to translate it. It was my way of meeting everything inside of me, with dance becoming a primary avenue for self-expression and self-discovery." It was a personal joy.

Forest refers to "the second opening to this river" which came

during her teens through choreography. "Choreography is the architecture of movement and nonverbal storytelling. It engaged me in the creative process," she says. "It provided a way for me to intentionally explore, integrate, and communicate my inner world." Importantly, in choreography audience is considered.

Today as an adult, Forest is now able to state in words the effect dance had in her development as a young woman: "I used to open myself up to what needed to move inside of me and it would find its way out. I would dance and dance until the rush of what had moved through left me empty. As I danced into a state of emptiness, I would feel moved by something else. I'd be peripherally aware that my body was carving through space in ways that I could never consciously contrive or plan. I felt outside of time. I used to dance to transcend the limits of my body."

At twenty-five years of age Forest was coming into the prime of her life and career as a dancer. It was then, as an active and competent practitioner in the art of movement, she discovered that she had cancer.

" I diagnosed it myself after reflecting on a puzzling dream. First, I actually noticed a lump in my cat's neck." Feeling the odd lump beneath the fur of her pet somehow alerted Forest to palpate her own neck, where she felt a similar lump. This experience raised a new reverence in her, along with new questions regarding the nature of the 'mind-body' relationship.

The appearance of cancer brought about a change in Forest's relationship to dance.
"I used to dance to transcend the limits of my body," says Forest. Gradually, I danced to stay in my body."

Forest's experience with cancer represented what she calls the

third opening of the river. Her comprehension of what dance was able to achieve was enhanced dramatically. Her image of dancer as "artist" and "choreographer" broadened to encompass something new: Forest discovered the profession of dance/movement therapy.

This field is defined as: "the psychotherapeutic use of movement as a process that furthers emotional, cognitive, social and physical integration of the individual"[1]

It was the only thing that made sense for her to pursue. She went to Graduate school and began working as a dance/movement therapist. She was answering her calling. From then on, Forest's personal and professional relationships to dance as a force in her life became intimately intertwined. The fourth opening of the river of dance took place with her introduction to a contemplative discipline called Authentic Movement.

"As I practiced this discipline of Authentic Movement, I encountered within me a place where all the aspects of movement as I had experienced them met. Through this discipline, I was able to reliably source that which feeds the therapeutic, artistic, and spiritual dimensions of dance." All of her experiences in life were linked together.

Authentic Movement is a practice of mindfulness that develops the capacity to consciously track inner and outer experience, not just to one's self but also while relating to others. "It is a movement practice that has no movement agenda," she says. "Its focus is the intention to practice conscious relationship to direct experience in the context of moving and witnessing." It involves the heightened awareness of the physical, mental, spiritual and emotional.

1. Levy, F.J (1992) *Dance Movement and Therapy: A Healing Art.* Reston, Va. NDA, AAHPERD

A new level of mastery was reached. Yet, Forest's life pattern seemed to be one of physical exploration, and adapting her skills to change. As if on cue, another trauma occurred to challenge her newfound personal joy. Four years after being diagnosed with cancer, she was involved in a car-accident.

"The Physical pain of the accident called me to understand and feel the very real and finite edges of my form.
When this first happened, I felt devastated; I felt confined to the territory of my muscle and bone. Physical sensation monopolized my awareness and anchored me into the here and now. My relationship to moving greatly changed again as the crash left significant, chronic pain in the map of my body and I practiced Authentic Movement within new physical limitations."
Ironically, when she finally surrendered to her pain through this discipline, the sensations led her more deeply into her own body, where a new quality of spaciousness opened up from within. She moved into a new state of emptiness: It was her body, learning to be in relationship to its new state. She received an unexpected gift: She was more sensitive to the subtler levels of movement within her. This led to an even deeper relationship to her body, which enhanced her effectiveness with her clients. Her capacity to perceive somatic expression became more acute and more finely tuned. Forest's ability to help heal others would only be born from her own ongoing healing:

"The further I have entered my body," She says, "the thinner the distinction has become between my experiences of embodiment and of transcendence." Now when she works with others in the realm of movement, it "includes everything from breathing to choreography, from hidden movement within the body to outright dancing." It is a journey into the unknowable. "I enter this nonverbal stream of expression, communication, and impulse and find, sometimes, a meeting place with the

other person. From within this place, we discover a dance. The dance is a relationship to each other and
to our selves. It is a dance of grief or joy, humor, or rage. It is a dance of protest, or of celebration."

Forest's profession has led her to demanding situations as she uses her skills to reach others. Working in psychiatric state and university hospitals, substance treatment and
care facilities, she has taken her healing art to environments that could test the faith of any person. The following stories are about real clients of hers, (although certain details have been changed here to protect the identity of the clients.)

Patient A: This was a woman with one side of her body paralyzed from a stroke, confined in a wheelchair.

"She would scream and hit staff and sob at the door leading out. I took her into a room in the middle of one of her attacks on staff and put music on. Her face changed. She moved her one good hand, her arm and finally her torso. She led me into a dance with her and we mirrored each other, partnered each other, laughed together…she rested her head on my chest. Our relationship went through many varied transformations. Our language was purely movement. When she couldn't get out of bed, I brought the music to her and put my foot up by hers so we could dialogue with our toes. When she felt only like yelling and howling, I started to dance the sounds of her voice: I'd match the ups and downs of her tones with the softness or strength of my movements. We continued this for entire sessions. I worked with her for two and a half years. "

Patient B: A man in his sixties.

"He was tormented by hallucinations and a history of homicide. I would play a particular Mowtown artist every time we had our dance therapy group because he would start smiling

and displaying o his suave shuffle-style steps which he would gladly teach me. One time when we were dancing together, "meds!" were called and he dutifully went to stand in line in the facility's corridor. But his face was lit as he stood in line, and he kept dancing (and I with him).

Patient C: A young woman with first psychotic break.

"She wouldn't make eye-contact or acknowledge any attempts by staff or peers to interact with her. I went to her bedroom to invite her to group (as we group therapists do)
and saw her on the floor in a fetal position. I walked in and curled up on the floor in the same position beside her. I waited."

"She turned her head sideways and looked me in the face. We looked at each other for a very long moment. I then said, "I'm going to have a group right now in the other room and you can come with me if you feel like it." She silently unfolded out of her curl and walked with me, as if waking up, into the other room where she continued to begin
relating to the world around her."

Patient D: This young man came to the hospital in a vegetative state after being physically assaulted.

"He had not spoken since the event. She was sitting away from the others holding a piece of paper and a pen in his lap. I crouched beside him as he stared blankly. Music was audible on the CD player. He began, suddenly, to write, -his first communication, to my knowledge, since the trauma. "I wish I could dance to the music."
I read his words and listened to the music as it continued to play. I said "sometimes, when I can't dance with my body on the outside, I still dance to the music on the inside." He did not indicate any response. After attending to another patient, I looked back and saw that he had written more words: "Then I

will dance on the inside even though my name is gone." Tears were running down his cheeks. Yet, his recovery seemed to accelerate in the next few days."

As Forest dances to balance her self, she touches and impacts the lives of others in ways she could never have imagined when she first began on the path.

 "The artist's vocation is to send light into the human heart."

-George Sand, Novelist

Renewal

An aura of piety and gentleness is implied if we speak of art as a vehicle for cleansing and healing. Can art softly caress those who experience it, like soothing water? Can the act of creating art heal the artist who created it? Does art function like a ladder - leading the practicing artist out of depression, like a shining light in the darkness? The romantic notion has been that the healing properties of art could be thought of as a kind of vacation from a harsh reality. While a relaxing interlude with art may be conducive to rejuvenation, art carries the reputation of being the chief ingredient in a life changing process of a most profound magnitude. Yet it may be argued that "art" does not heal.

Rather, the artist who is finally able to focus through art becomes quieted enough to heal him or herself.

The ability to embrace courage as an artist takes many forms. All forms are meaningful, in that they reflect our true character. Creative people bring with them a degree of self-doubt, misconception, trepidation and emotional baggage. They also display a sincere confidence in themselves, even when their self-image has been weakened. Art becomes an incredible energizer, re-animating parts of us that are in jeopardy of falling asleep forever. In every artist there is a seed of real courage. Some of us exude it, radiated it, while some of us keep it dormant. The seed is saved, like a warm jewel that blossoms in the depth of winter. Through art, people may transform into their highest selves at vital points in their life story.

Judith Bloch represents another individual who has used art as a vehicle for self discovery and healing transformation. I suspect that she also represents many people who have let courage flow from their heart, to supersede fear and illness. In her youth, Judith was part of the peace and consciousness movements in the 1960s. She joined the Peace-Corps, traveling to Africa, where she did humanitarian work. As she entered into maturity, her life unfolded in a number of challenging ways. She survived an abusive husband and a flawed marriage, then went on to work for the State of California in youth Corrections, processing troubled teens through the legal system as a deputy Probation Officer. Later, she underwent ten operations resulting in a kidney transplant. Perhaps this transplant had the greatest effect upon her life as an artist. She began to understand the greater process of re-creation.

As Judith puts it," Our society fears the natural cycle of life and death. The process of creating art is an antidote to that fear."

When she speaks about "The Process" she refers to the visualization of the artwork, the use and misuse of materials, the planned and unexpected results. She realizes the time spent in the process of creating is the only way to meaningfully create. She now recognizes discomfort and anxiety as part of the process. They are places along the road. They can be experienced, but she finds no use in lingering there. Judith began producing art as a way to manifest healing, in her self and in the lives of people she meets. Lack of a vast workspace at home does not stop her. She lives in a humble apartment, choosing to spend her money on world travel, and workshops, where she can network with other artists, and learn new approaches to creating. She delights in Eastern mandala painting as well as traditional western portrait painting. Now she teaches others now how to embrace strength through making art.

"Fear Forward!" She proclaims. To her it means: Fear is there. Big deal. Keep going ahead. She points out the most wondrous observation: "Courage has some fear in it."

 *"...To watch us dance
is to hear our hearts speak. "*
-Hopi Indian Saying

Reclaiming Our Self.

Art plays a personal, intimate role in the habits of most of us
when we are tiny. Some of us abandon the relationship with
art making for a variety of reasons. Lack of family support has
been responsible for the death of many dreams, and yet, many
great creators came from families that never really understood
or supported the artist's life. Collectively, our own self-critical
voice has certainly ended more of humanities creativity than we
could possibly imagine. But the most common way in which we
lose our connection with art is very quiet and very plain. It is
the lack of ability to continuously fit art into our growing lives.
The act of rediscovering, revisiting and rekindling the drive
to create art once it has lain silent reflects a great potency, an
archetypal return to vitality and a symbol of commitment that
could very well unfold upon the path of all of us.

Sophia Venable's relationship with her own art has been life-
long and has gone through many changes. When she was
very young, she began ice-skating at a local rink, where she
developed the focus and skill of a serious athlete. Along with
the exquisite sensations of her blade gliding upon the ice, there
came a strict rehearsal schedule, where talking with little friends
was frowned upon, where brands and styles of costumes became
emblems of economic class, and countless hours were spent
practicing routines, all alone. When not skating, she would
train seriously in ballet with a strict Russian teacher.

"I reached the point where I was required to have only one goal
ahead of me, which was to compete in the Olympics," Sophia

once explained to me. "There would need to be total focus from me, total immersion, complete solitude if I were to try to make it that far. I remember thinking that instead, I really wanted something else: I wanted friends."

She made the decision to pull the plug on her ice-skating. Middle School and High School brought new opportunities for Sophia to become involved with different creative arts. Drama, singing and jazz dance became areas where she quickly excelled, and she began playing roles in school productions. Her new pursuits brought her the friends that she wished for. Beyond high school, her pleasure obtained from musical theater was supplanted by her becoming a working performer.

"I really felt connected to the world of the stage", She says. "Going to auditions, developing intense relationships with fellow actors, rehearsing until everything worked together … It was exciting. And the shows where I got to dance, even in the chorus, were always the most fun." Yet as productions opened and closed, the true demands of her lifestyle made her aware of the intensity that was involved with her direction. With much success and a strong stage presence, Sophia again reached a portal that required a choice. She knew in her heart that if she continued, she would have to commit to living fully as a professional performer, living on the road from job to job. She sensed that, for her, this professional path was not going to bring her the eventual family of her own that she wished to have. She went back to school, pursuing another career, and family life. She married and gave birth to two daughters. During the next 12 years, with theatre no longer her vocation, she didn't dance or perform at all.

Again, love for performing arose within her. Dance and movement had been a major aspect of first years of her life, and after time away from it, her soul was aching to return. She allowed herself to do so, this time with partners, beginning at a high-profile dance studio. Social dancing was becoming reborn,

not only as a revitalized youth activity, but also as a form of entertainment, as a number of highly rated television programs captivated audiences in America.

Energetic and bursting with creativity, all of her talent had been in reserve, and she found herself eager to revisit dance as a social art, and more importantly, as a personal discipline. Her natural talent helped her take on ever-growing challenges. Her sense of intuition and confidence grew and became noticeably more acute. Sophia says, "My dance teacher and I had put together this cha-cha routine. While we were practicing it would suddenly hit me that I was dancing again. I was dancing! With joy! That feeling of needing to be technically correct- to be a professional- was gone. After so many years, I was finally dancing only because I love to dance."

She continued, "It sounds silly, but I would always listen to the song "Let's Get Loud" in my car and imagine us dancing that routine in front of a cheering crowd. I shared this little fantasy with my husband. Then one day, the dance school called to say that they needed dancers to perform Cha-Cha and Swing at a competition to be held a major sports arena in Los Angeles, in front of thousands of people. I had dreamed it, relished the dream, and here it was…coming true. When all the couples were on the floor for the first time to dance their cha-chas, the announcer informed us, 'you'll be dancing to the song, Let's Get Loud.' My husband turned to me at that moment and said 'well, it's your night, baby!'" And indeed it was. Sophia and her teacher won the competition. Years of work and set-aside passion culminated in a sudden flash of revitalizing fire.

It is the love of creating that keeps the art active throughout our personal stories, causing us to sense it not only as a professional source of income or even as a form of enjoyment, but as an indicator that we are truly alive. Art does not leave us. It will be there when we are ready. But, we must feed it.

 "How can I be useful?
Of what service can I be?
Is there something inside of me?
What could it be?"

-Vincent Van Gogh, Painter

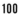

Missing Children- Paintings of Hope

This book began with a story about drawings I made while trying to keep dignity alive both in a distressed boy and in myself.

My own personal call to courage as an artist was the result of many forces in my life coming together, requiring me to act in different ways than I ever had before. Looking back, it seems ironic that my life's most important artwork sprung from disposable items that I had looked at for years, but had not really seen, until I had the courage to do so.

Fresh out of college, I found work as an art teacher at a facility for disturbed children. One morning while checking attendance, I noticed that the seat belonging to a strawberry-haired 10 year old freckled face girl was empty. Later that day I was told that she had been abducted, and that Police were investigating the matter. The empty seat in my classroom weighed heavily on my mind and in my heart. In the evening when I got home, I checked my mail box and found that among the letters and bills, I also received a mailer bearing the face of a missing child. "HAVE YOU SEEN ME?" the mailer asked. It featured a little boy in another state, but that day the topic of missing children had been a dominant one in my mind. I realized that I had seen these mailers for years but had simply thrown them away without another thought. Now that one of my own students was reported as missing, I felt a connection to this tiny blurry photo of a child I had never met. This time, I could not throw the card away. I kept it in a drawer.

101

Week after week, these cards came in my mail. I kept them all, understanding that behind each face was a story of a family and a child. One evening, I opened the drawer and spread my stack of "HAVE YOU SEEN ME?" cards on to the kitchen table. There were so many faces, so many stories. I thought that it was sad that these children had been reduced to being faces about the size of a postage stamp. I suddenly had a recollection about the words a jaded professor had said to me years ago while in college. I was studying to become a portrait painter, and a professor was lecturing me about what a waste of time portraiture was. it was the first experience I had ever had that involved an adult actively attempting to dampen my passion. I remembered him smugly proclaiming: "portraiture is old-fashioned. There is nothing you can do with it that would make people care". His words had been designed to deflate me. Now, years later, I felt compelled to create a painting of one of these missing children. It didn't matter to me if portraiture was old fashioned or not. I cared.

Holding a random mailer in one hand and a paintbrush in the other, I took cues from the dry descriptions of eye color, hair color and age. In a matter of hours, I had created a full color portrait of the child featured in the photo. I added additional vibrancy and activity to the paint, to coax the portrait to life. This completely transformed the little junk-mail image into a work of art.

I began painting more and more portraits of missing children. I would always start by holding the flier and sense through intuition how to approach the new painting. Some children's faces seemed to suggest a poetic approach. Some faces suggested realistic colors, or a more expressive interpretation. Each portrait became a very emotional experience for me because I could not easily separate myself from my own feelings about the subject matter. At times, painting the faces of the missing children became overwhelming. After two years, I had thirty paintings and I had not shown them to anyone. When people came to visit my studio, I always

tucked them away and displayed other artwork that I thought was more attractive or impressive. When I did share them, powerful emotional responses led to long conversations about family, safety, loss, and gratitude. As more and more people saw these paintings, I realized that they were able to touch people in a real way. Beyond the identity of the child in the painting, a portrait would trigger a multitude of personal responses from viewers.

I was invited by a gallery director to show the paintings in a solo exhibition in Los Angeles. Once hung, I carefully wrote the personal information about each child in crayon directly onto the wall beneath each portrait. The exhibition was very moving and successful. I began painting other subject mater, but continued to paint the face of every missing child from the fliers that appeared in my mailbox. Over time, the paintings numbered in the hundreds.

The question became: What was I going to do with all these paintings? The answer was simple. I needed to exhibit them. But how? Because of the subject matter, and because they were not for sale, I was having difficulty finding a gallery venue for them. What I really wanted was a way to display the paintings in public, outdoors in the sunshine. I wanted the paintings to have a deep emotional impact on audiences who were not anticipating art.

Someone suggested portable walls, upon which the paintings could be displayed. I didn't like this idea. Who wants to lug walls around? Wouldn't it look just like any other exhibition? What if a wall fell over?

A solution appeared in my mind: What if people held the paintings? This solution transformed into a vision: Hundreds of people gathering in a place, each holding a painting of a missing child.

My heart raced. This was the breakthrough.

Of course, as quickly as the vision came, I was flooded with doubts about how to proceed. I had to act fast to overcome any further procrastination so I resolved to launch a public exhibition of the paintings in one month. I decided that the first location of my project had to be somewhere big, somewhere that would attract people and media coverage. I chose the entrance to the Los Angeles County Museum of Art. The next weeks were frantic. Emails and phone calls were made to literally everyone I knew: friends, students, family members, and collectors. I enlisted them to be a part of my exhibition. I went through the process of securing permits and procuring permission from the museum for the intended day. I also devoted great effort to developing a media plan, contacting television and print reporters. The last evening before the event found me stapling straps onto the back of my paintings, making them easier for participants to carry. All of this represented a great leap of courage to me. It felt like planning a huge party, and along with the thrill came the fear that "nobody would show up."

I called the event "Missing Children-A Gathering". My intent as an artist was to break the traditional boundaries of art by having participants actually handle my paintings. I hoped to have the paintings take on a kind of life that they would never have hanging passively on a gallery wall.

On the morning of my planned event, I became giddy as hundreds of my friends and family arrived to help and participate. My sense of being an artist working alone in my studio would vanish forever. As hundreds of volunteers stood shoulder to shoulder in a long line along Wilshire Boulevard, they each held a painting of a missing child. For them, it was literally making a stand for that child and their family. Beneath each painting hung the actual "HAVE YOU SEEN ME?" card that inspired the artwork. As audiences walked past to enter the museum, they could experience the many paintings and the message. So many people stated " I usually just throw those

cards away", and I knew that they would see them differently after that day.

The media covered the event. It was featured on television news that evening. I was interviewed on two live radio shows. We also appeared in color on the cover of the Los Angeles Times. It was an exciting start. It was exhilarating.

Within days I received a phone call from the President from the California branch of the National Center for Missing and exploited Children. She had seen the gathering at the Los Angeles County Museum of Art and wanted me to attend a meeting at the national center headquarters in Virginia. I flew out to present my project to them, and announced that my next event would be held at the Lincoln memorial in Washington D.C. on National missing children's day. They were impressed enough to support the project as well as cover the cost of airfare, hotel, and ground travel for myself and a team of assistants. I didn't even ask them for that. It was offered.

When I returned home to Los Angeles, I was excited to relay this information to my wife. I realized that I had a lot of work to do. Here was my new vision: Hundreds of volunteers would take turns holding a painting of a missing child while standing on the steps of the Lincoln Memorial. Because this is such a heavily visited tourist place, our audience would be huge. The first thing that had to be done was selecting participants. My wife Martina is fabulous at coordinating. She spent countless hours contacting youth groups, churches, schools, arts organizations and politicians. We sent out invitations, brochures, and fliers. I got to thinking that we could use some music at the event, so we procured a Virginia -based hundred person gospel choir, with a soloist and backup band. We rented sound equipment and hired a board operator from the largest mixing company on the East coast. Noted politicians were scheduled to speak about safety legislation. A videographer and sound crew offered to tape the event at no cost on a state-

of-the-art high definition digital camera. I also hired award-winning photographer Toni Scott to capture stills. Shipping of the two hundred and fifty works of art was donated by one of the largest freight companies in America.

As the clock was ticking down to the weekend of the event, every day was filled with many details and arrangements that had to be made. When it came time I did a number of newspaper interviews, discussing my vision for the event.

We all flew into the D.C. area together and arrived in Alexandria Virginia. My team of assistants, the photographer, and video crew all met to plan things out and get familiar with the locations: In front of the White House, and the steps of the Lincoln Memorial in Washington D.C. All of the art had been safely shipped. Cameras were loaded. Ground transportation was prepared. Permits were secured. Musicians were set to go. The evening before the event was electric.

We awoke at 6 am. My mind was gripped with total fear. What were we doing? How were we going to pull this off? Everything was based upon faith. Did I have any? We all met downstairs in the lobby for breakfast. It was then that we heard the television news. It seemed that a huge storm was slated to crash into the D.C. area that day. I can still hear the weatherman as he described the pending flooding, high winds and lightning. He actually predicted that it would be one of the worst storms in memory. My heart sank. I became woozy. I searched the faces of my team and found no sympathy for my discouragement. They refused to acknowledge that they had just heard anything negative. My assistants were incredible at ignoring the news and giving me hope. I realized that I had to set a strong tone for the rest of the day, and events were going to unfold as they were meant to. It was truly out of my hands now. I had to follow through. I had to have total courage. Only my ability to give up concerns for the outcome made it possible to continue.

106

When we arrived by van at the White House, we went about our plan as scheduled. It was cold and drizzle was in the air, but I focused on the task before me. We set out dozens of the missing children paintings, simply leaning them up against the safety pylons running down the street. Security teams flew into action to work with us, and we produced all of our official documents and licenses for their inspection. The Video team had set up the camera and boom right in the middle of the pedestrian walkway. Within minutes, our first participants pulled up in a long tour bus.

Out jumped eighty teenagers from Texas, on their spring senior trip. They were met with a misty spring view of the nation's White House, and an unexpected row of colorful painted faces. It had begun.

After taking snapshots of the mansion, the teens started examining the paintings, along with the original little "HAVE YOU SEEN ME?" cards which were laminated and attached to the bottoms of each one. They had to crouch down to read the cards. They milled around, going in groups from one painting to the next, asking their chaperones about the art. Who did this? Why were they here? What was this for? The cameras were running and the microphones were on. The time was right. Like in a dream, I heard myself come to life.

"Excuse me, Hello." I called. I waited for their attention. Their murmuring stopped and their eyes rested on me.

"Would you like to take a moment to hold a painting of a missing child over your heart?"

There was a silence. My ears burned. My throat went dry. It was like a stand off, where the next person to speak would decide the response for the group. I waited.

"I'll do it." It was a teenaged girl with a rain coat and a floppy hat. She courageously picked up a painting and stepped forward. I showed her how to place the strap over her head, so that the painting hung before her like a sandwich board. "I wanna do it too," another teen said.

"Come on, let's do it," another responded. Activity and excited talking broke out in the street. They all wore a painting, and stood as a group. I could tell that there was an amount of focus taking place. The giddiness washed away and a light rain began. There stood eighty teenagers in front of The White House each wearing an oil painting. The silence was incredible. I spoke, finally.

"These are paintings of America's missing children", I said. Hanging from each painting is a little card that tells about the kids. They began reading each other's cards, some exclaiming with emotion at what they discovered.

One young man called out a question: "Who painted all these?" "I did", I said. I painted them from those little cards." And then, something beautiful happened. A boy called out quietly to the group, "Let's pray for these children."

Immediately, wordlessly, everyone fell silent again with their heads bowed. It was so matter-of -fact. A few teens began to cry. I began to cry.

After a few moments, they all removed the paintings, placing them carefully against the pylons. While they piled back on the bus I talked with their teacher about what we had just witnessed. The rain stopped, and two new buses of participants pulled up. The scene was repeated over and over and over.

This continued for hours. Group after group appeared. Some were from schools. Some were vacation tours full of families. Every time, I spoke the simple sentence: "Would you like to

take a moment to hold a painting of a missing child over your heart?"

As the crowds swelled, the paintings were handed off from one group to the next. The emotion was so powerful. The questions and comments were so meaningful and insightful.

"You can't touch paintings in Museums," a little girl told me as she smiled and gripped a portrait.
In their own ways, using their own personal language, participants told me about the impact they felt from holding a painting, and how much they appreciated the idea of a single artist creating such a tribute.

In the early afternoon, we drove the paintings to the Lincoln Memorial. The location is incredible. The architecture and history is exhilarating. I was so full of strength after seeing the impact my art was having on people, that the sudden turn of events hardly penetrated me. It seemed that the threat of a huge storm kept our hundreds of volunteer participants away. The choir cancelled. The musicians cancelled. The politicians did not arrive. The expensive sound guys refused to set up even a microphone for us. Only two volunteers from a local woman's group showed up as promised.

"What should we do?" my head assistant asked me. Without hesitation, I responded.
"Put the paintings flat on the steps." And so, we placed all two hundred paintings of the missing children in rows, down to the reflecting pool. I realized immediately the greater lesson at play. I did not require additional musicians, vocal soloists, choirs, politicians or even sunny days to fulfill my mission as an artist. We simply laid the paintings down, and stood back. The Lincoln Memorial was a gathering place for tens of thousands of visitors. People discovered them quietly, and then explored each one, crouching down, even to touch them. The faintest most delicate mist fell from the sky, but the light was beautiful.

No storm ever came to disrupt the day. The paintings became an installation. They were meant to be experienced in such a sacred place intimately.

Now, I did not even need to speak. I could detach, and allow the paintings to speak for me.

Among the thousands of viewers, some extra -important people attended. One person was Vince Guiliano, the founder of ADVO's "America Looking for it's Missing children Program. It was he who had begun printing the "HAVE YOU SEEN ME?" cards that feature the missing children on them. He was glad to see so many people stopping to take a look at the exhibition. He had driven from Connecticut to see the paintings. Two other incredible people were Sam and his mother Abbey. Sam was a young boy who had been abducted. I had painted his portrait from an ADVO card years earlier. He had since been safely recovered, and now wanted to stand on the steps of the Lincoln memorial amidst all the other paintings, wearing his own portrait. He was a living testimony to the power of those cards to find kids.

This was one of the greatest days of my life. I broke through so many fearful urges while making an impact on my audience. I grew in many ways that weekend. My heart felt huge.

Missing Children- Paintings of Hope

"Let us descend now into the blind world,
Began the poet, pallid utterly.
I will be first, and thou shall second be."

–Dante, Inferno. canto IV

Art During War

What a luxurious dilemma we are in. At our leisure, we can discuss the role that courage plays in the creation of art. We live at a time when we have brought art making into the realm of therapy. We fret about the obvious. Should we be more imaginative? Should we act decisively? Should we risk exposing our inner selves for all of the world to see? Of course the answer is yes. Most artists have pondered these questions. Some of us now pay professionals to listen to our quandary from the comfort of a warm sofa. We can appreciate our luxurious dilemma more when we look into the lives of people who created art during real times of darkness, in the midst of a war.

A time of darkness is when courage must flow freely. It is also a time when art making may be viewed by some as an extremely trivial pursuit. Yet the creative voice singing in the midst of collapse has a special ring. It is the voice which says: "I am alive." To be vocal during a crisis, to be a poet in an onslaught of terror requires verve. To do so with grace, compassion and articulation is the highest calling. Actually, the political message of art made in times of war is always secondary to it's very creation. Especially in times of war, creating art is a political act unto itself.

As we read these stories, we must be certain not to romanticize. We must not allow the names and places to make us feel that we are delving into past history. We must remember that while we read about these artists we are reading about ourselves. We are reading about situations which to some extent or another,

are occurring somewhere today. In many places, creative artists are undergoing their own challenges and real battles in countries riddled and overtaken by violence, injustice and upheaval.

The tangible present has been born from footsteps leading back to a not-so-distant past.

Art During War

"Art is a noble mission.
Those who have been chosen by destiny
to reveal the soul of a people,
to let it speak in stone or
ring in sounds, live under a powerful,
almighty, and all-pervading force.
They will speak a language, regardless
of whether others understand them.
They will suffer hardship rather
than become unfaithful to the star
which guides them from within."

-Adolph Hitler. Nuremberg speech, Sept. 11, 1935

Portrait of the Artist as a Mother

The fact that Kathe Kollwitz was an Artist-Warrior made all
the difference in her journey. It ensured that she would not be
barren after her losses. It ensured that her existence would not
be erased by the cruel boots of evil. The choices she made about
her art, above all, ensured that there now exists a record of her
pain, her strength and her amazing life...

Kathe would not crumble. She would not embrace a false ideal
in exchange for promises of safety. For this, Kathe (pronounced
KAY-teh) is a champion hero and a model that all humans
should hold in their heart. She is the embodiment of art and
courage. Kathe's art is like a time-released message to us, sent
from a past century to our own.

When I first saw a work of art by Kollwitz, it was a defining
moment for me. I was eighteen, in art school, and had bought a
book on "expressive drawing". My first exposure to Kollwitz was
her lithograph, "A woman with dead child."

It resonates with the greatest strength and the most authentic
sensitivity I can imagine. The design appears as if a rock has
been tossed into a pond, and the ripples have radiated outward
from the center. While Kathe was a master of human anatomy,
she does not waste our time, or her own, by rendering every
body part simply for show. She selects the most vital elements.
It is anatomy in action and anatomy with meaning. She gives
us unflinching clarity and soft mystery while she conjures
horror and intimacy. Line merges with stain and death marries
life. She created the image by looking at herself, posing in front

of a mirror cradling her own eight year old son, Peter. It was to become a prophetic Image.

Her messages trigger emotions of anger, compassion and pain, but she did not use art like a personal diary. She had an ability to understand that her experience did not belong to her alone, but was, and would sadly be, shared by so many mothers across time and space.

Kathe Schmidt was born on July 8th, 1867 in a city named Konigsberg in Prussia. She was raised by a strong and caring family. She studied painting at an early age, and was soon enamored with the expressive techniques of etching and printing. Ink drawing was her real passion. Line work and graphic black and white presentation gave voice to her style of realism. Having visited Paris and Venice and seen much of the current style of colorful Impressionism, Kathe's choice to remain a creator in black and white was an extension of fellow German artist Max Klinger's view that "Some themes should be drawn rather than painted. Some themes would be ineffective and even inartistic if rendered by means of painting." Klinger taught that the weightier aspects of life were reflected better this way. She embraced this belief, and immersed herself in drawing and graphics. She was preparing herself for her future.

In 1891 she married a young Doctor named Karl Kollwitz who happily set up a studio space for his bride and then set up his own office across the hall. It was this situation that gave Kathe intimate views of illness, poverty, malnourishment and especially the plight of poor children in her community. Politics and history began to play heavily on her mind, and her primary successes as an artist came from a series called "The weavers." It was one of the first bodies of art created in which a struggle for a better life by workingclass people was depicted sympathetically. When displayed at the Great Berlin Art Exhibit in 1898, a

distinguished jury awarded the Weaver's cycle with a gold medal.

Kaiser Wilhelm II feared The Weavers' social content however, and referred to Kathe's work as "gutter art." He personally blocked the award from being given. This Veto was only the beginning of the censorship and discussion that would ultimately surround her creations.

The looming Success in her career was soon matched by happiness in her life as a wife and mother of two sons. Then came the onset of the Great War of 1914. Her youngest son Peter who had posed in his mother's arms as an eight-year old had since grown into a young man. Like many, he had become filled with pro-military rhetoric and volunteered to be a soldier. He died days into his service. As his mother, Kathe never recovered.

Yet, Kathe the artist was empowered by this personal tragedy. She became the voice of a cause that could not have been more passionate. Her previous cycles of workers' strikes and etchings of peasant rebellions were ultimately mere rehearsals for her own stand against war, or more specifically; a stand against those who destroy youth in order to employ them as soldiers.

One of her favorite axioms was "Seed for the planting must not be ground up." The seed she spoke of represented the promising generations of children who are systematically erased by the ever seductive war machine. Her work became unflinchingly social as she created art to rally viewers against hunger, political corruption, abuse, and apathy. With her bold graphic style, she pleaded for compassion and action. "Peace" after the end of the war meant only humiliation and despair for the powerless citizens of the defeated Germany, and the treaty of Versailles left the Nation unable to fully reform. It took an opportunistic dictator to fan the embers of bitterness and despair into high reaching flames of ravenous nationalism.

Adolph Hitler had been a frustrated artist himself in his youth. He had received poor response from his architectural drawings as a student in Vienna. Along with his plans to create a new Germanic empire, he believed that art had been corrupted by contemporary ideas and anti-military social messages. When he obtained full power, newly blacklisted artists across the country were pressured to stop painting and forbidden to exhibit. Kollwitz herself was forced to resign her position as an art instructor, and her works were removed from public museums. Weakened, she was then "courted" by the Third Reich, who wished to have her return to the fold and retain her place of honor as one of Germany's greatest artists, if only she would renounce her previous work and produced art along party lines. While thousands of other citizens in all walks of life submitted to this kind of fascism and desperately sold out, Kollwitz would not.

So, her work became illegal. Her shows were shut down. On one occasion she was threatened with being sent to prison for not cooperating with the Nazi police. When the newly constructed "House of German Art" exhibited eight hundred examples of Nazi approved canvases and sculptures, she was not invited. Nor was she included in the infamous Degenerate Art Exhibition, where examples of art deemed unclean and unfit for viewing were mockingly put on public display in a kind of "house of horrors" freak show. Worse perhaps than being ridiculed, Kathe was purposely ignored.

She remained in Berlin as many of her artist peers were purged from society. Most fled or were imprisoned. She worked in private, and sent her drawings to New York, where she developed an enthusiastic following. With the outbreak of World War Two however, her ties to the U.S. were severed. As Nazi propaganda boomed that Germany was winning the war, soon the truth was obvious. Allied planes launched unflinching retaliatory attacks against German civilian centers. Her own home was bombed during the intense air raids by

allied planes, and her Grandson was among the dead as the country fell. She passed away on April 22nd 1945, just a few days before the total surrender of the Nazis, not knowing peace or the outcome of the War.

Her final great artwork was the monument to all mothers and fathers of dead soldiers. Her sculpture, "The Mourning Parents" depicts two life-sized kneeling figures gripped in physical and internal torment. In the Christian pieta, a mother is traditionally shown cradling a dead Christ. In this piece, Kathe gives us no body to mourn. Instead, there is only a void... An empty space between the two anguished parents. It is a self-portrait of the artist and her faithful husband created for a cemetery in Belgium. A replica now stands in the preserved ruins of the Saint Alban church, beside the Rhine river in Cologne, Germany. Cologne is also the home of the intimate and comprehensive Kathe Kollwitz Museum, which was specially built to reflect the mood and scope of this amazing woman's commitment to the preservation of life. A second museum dedicated solely to her art is in Berlin.

For all of the darkness and visions of struggle that emerge from her graphic work, it is her strength that is victorious. Unlike many pessimistic artists after her, Kollwitz created art which is firmly planted in the knowledge that humanity can live in a civilized realm of dignity and love. It is this love that keeps her images from becoming merely horrific. It is the dignity that helps her work transcend the mere political. To think of her message as being linked to a long-gone European crisis is a great mistake.

Our own age is ripe for the message of her universal artwork. Every day, one can watch the news and observe life torn apart by car-bombs in the name of retribution, or air strikes in the name of liberation. It is the numbingly cliched and constant story of our advanced epoch. Based on the regularity of the cycles of history, we may wonder how many of us could hold to

our heartfelt beliefs as firmly as Kathe did if ever faced with the choice of conviction over compromise.

Kathe hoped for a change in this cycle. As she passed away in the last days of the second world-war, she could have only hoped that the people and cultures of the Earth would somehow survive. She probably wished that her art would speak to others in a future century, to remind them that we all share the same salt in our tears, the same habits of heart and the same ability to refocus when we are led astray from the path of wisdom and peace. Kathe devoted her life to creating a warning mechanism, a gift which she intended for us.

Throughout history, the treatment of artists by their respected governments seems to be the canary in the coalmine of civilization. When the arts are free, people are free. When arts funding is up, culture flows. When art expression is valued, fear disappears. When these fruitful rules are not in play, the opposite will be true. We should allow ourselves to question the direction that a half-a-dozen or so world rulers are able to steer the Earth.

Kathe did.

Portrait of the Artist as a Mother

 "There has to be evil,
so good can prove it's purity above it."
—*Buddha*

The Artists of Terezin

The sunlight was breaking through the sky in Prague on
the day I discovered the artists of Terezin. A delicate mist of
a rain had fallen earlier, giving the illusion that the dust left
by the former Soviet-Union had been freshly washed away,
that the tired, glorious city of spires had been reborn for my
wife and I just for our honeymoon. We walked through the
old Jewish quarter, now long free from Nazis, Soviets, Papal
emissaries, zealots and anyone else from past history who has
tried to wrestle control over this gorgeous, breathtaking city.
Only tourists now, by the tens of thousands, were intent upon
marching through the streets.

We walked solemnly through the famous old Jewish Cemetery,
where layers and layers of picturesque blackened headstones
stand in cramped, jagged formations, inches from each other.
The Pinkas Synagogue in Prague's old Jewish Quarter was
inviting, like a structure from a fairy-tale.
A sign mentioned an 'Art Exhibition.' So we entered and
climbed the spiral stairs to a gallery space. Simply-framed
drawings and watercolor paintings, obviously created by
children, hung accompanied by text in Czech and English. A
banner read "The Children of Terezin."

I stood with the silent crowd of viewers to gaze upon the first
colorful drawing, a ring of young girls, practically stick figures,
holding hands as they danced in a circle beneath a sunny sky.
The second drawing was a family, sitting at a table. All the
details were there, the kind that children like to meticulously

include. The marks were free and at the same time precise and economical.

The third drawing did not fully register in my mind for a few moments. I blinked. I realized that it depicted a hanging. Stick-figure soldiers in uniform stood by as a bound stick-figure victim dangled from the end of a gallows. Only then did I notice the wall labels. The name, age and date of death of each of the child artists was posted. This was a moving experience that I have not forgotten and which haunts me ten years later.

 Beyond the thousands of documents the Nazis left us, detailing the machinations of their actions, a unique collection of drawings on scraps of paper has something to teach us about the notion of courage. Although they were silenced, the artists of Terezin still speak.

Theresienstadt, or "Terezin" to use its Czech name, is a fortress-town, thirty miles north of Prague. In 1780, Emporor Josef II founded the Hapsburg village, with it's imposing walls and deeply cut protective moat, thoughtfully naming it after his mother, Maria Theresa.

Sixty years later in the early 1940s, the Nazi regime began scouting for appropriate places to house thousands of Jewish prisoners and Terezin appeared to be a perfect geographic and architectural situation. No "prisons" needed to be built, as the entire town could function as a unified holding center. Across the nearby river stood the "Kleine Festung" or small fortress, which would be a suitable jail for trouble-makers. The Nazi leadership in Prague contacted the heads of local Jewish communities with the good news that a special town was to be born just for them!

In November 1941, Terezin opened it's doors for the first inhabitants.140,000 would come to live there, and according to records 112,000 would die there. From the onset, Terezin

was meant to be a model. It was different from the other concentration camps that the Nazis built, in that Terezin was to serve as a waiting station, a home for the Jewish aged, and a kind of relocation community. In one of the most surreal scenarios in World War II, Terezin was originally advertised by the Nazis to be a quite livable place, even being referred to as "The Family Camp". The elderly especially were lured to willingly embark on the trains from Prague by SS leaders who acted as if they were promoters for a kind of resort vacation-package. Once Jews were registered, had turned over the keys to their homes and had packed their nice clothing, they were transported by train to the station just outside the entrance to the fortress. New arrivals came fresh off of the trains with their expensive finery, even expecting a private room with a view, furnished with beds sporting down pillows. Instead they were stripped, horded into over-crowded barracks, and fed a 900 calorie a day meal of potato peelings, or horse-flesh. Still, an illusion of civility was suggested in the ghetto due to embellishments that the planners had included. Terezin featured a café, a food store, various "shops" and even a "bank". Of course the food shops sold nearly inedible food stuffs, while the boutiques offered only the confiscated clothes and luggage of previously deported fellow prisoners. The phony businesses only accepted the Nazi's bogus "currency" which was utterly worthless. It was all fake, designed to disguise the evil.

Yet, the incredible thing about Terezin was that in spite of the artificial veneer, the growing deaths from illness and hunger and the real horror of the situation, there grew an authentic culture of public art. Remarkably, the Nazis allowed theatre and musical performances to go on relatively unrestricted within the ghetto. A jazz combo played for the teeming crowds at the "café" and the prisoners even began to regularly rehearse and present operas such as Carmen and The Bartered Bride, which was performed thirty five times.

The most popular theater nights in Terezin, however, were

when a production of "Brundibar" was to be performed. Hans Krasa wrote the children's opera earlier in 1938. It told the story of two children, a brother and sister, who sing to gather money to buy milk for their sick mother. They are tricked by Brundibar, the evil organ grinder, but with the help of friendly animal characters, the brother and sister defeat the villain and triumph. Year after year, the imprisoned children made up the ever-changing cast, and the cute presentation was not viewed as a threat by the Nazis, as is evidenced that the play was performed 55 times. It was seemingly harmless to the captors- especially since it was presented in Czech. Yet all of the inmates certainly understood the symbolism and meaning behind the story.

At first, a hierarchical order among prisoners existed. Those who had held the profession of teachers were on the bottom. They were broken first, sent to labor camps to perish quickly. Of all the other professions, to have been trained as a technician was the saving grace for many prisoners. After all, the Nazis were still constructing barracks, water systems, electrical systems, and gas mains. Architectural rendering and chart making was needed, and this skill was respected by the captors. Authorization to work on such projects allowed certain privileges. The Zuichenstube, or technical drawing office, was a haven for five Jewish artists at Terezin: Felix Bloch, Leo Hass, Bedrich Fritta, Karel Fleishman and Otto Ungar. Besides their formal tasks and commissions, after hours these artists took the opportunity to carry out the painfully courageous duty of documenting their own private experiences of life in a death camp. To this day their output contains some of the most evocative graphic images ever created. Hovering between reportage and poetic expression, these artworks make real for us today events seen and felt which most people could not otherwise know or imagine.

On small scraps of paper, cloaked within the protection of the throngs, or after hours when alone, the visual artists created ink and pencil renderings of daily Terezin scenes. In these

drawings, images of stage plays are shown being presented in the middle of over-packed squares and gutted attics. Groups of "customers" fill the tables at the "café", as waitresses serve drinks of questionable nature. The drawings that were most vital, however, illustrate the extreme conditions of filth, exposure, mal-nourishment and death that were daily facts for the thousands of prisoners. These scenes in particular are populated by masses of ghostly figures stooped in misery, laying invalid on cots in dank quarters, staring numbly into the nightmare that their lives had become. Their jobs, homes, spouses, families and possessions had been ripped from them. These drawings were acts of courage, boldly created with detail and expression, and were most dangerous for the artists. They were also dangerous to the Third Reich. While "friendly" drawings were openly traded in the camp, these drawings of the truth were expressly forbidden.

Somehow, the artists were able to smuggle a few of their most graphic, critical drawings to sympathetic friends in Switzerland. In doing so, the truth reached the outside world. As a result, the International Red Cross was pressured to pay a special visit to Terezin, to see this "model camp" that the Nazis had created. The inspection was designed to find out first hand how the Jewish prisoners were really being treated.

With the pending visit, a formal "beautification plan" was put into motion. Houses were freshly painted. Select buildings were scrubbed clean. Flowers were planted. Wards of unsightly sick orphaned children were sent to Auschwitz so as not to alarm the visitors. New sheets were given to the community hospital. A census was called, so that the Commander could accurately verify the number of inhabitants in the Ghetto. For ten hours, forty thousand prisoners were forced to line up in rows while the Nazi guards counted heads and verified identification records. People fainted from exhaustion, hunger and illness. After completion, over a hundred and fifty dead bodies remained in the field. In a jittery act of nail-biting just

days before the inspection date, an additional 7,500 prisoners were sent to neighboring camps to relieve the overcrowding. Pretty, youthful girls were especially exempt from the transport. The prisoners were forced to actively participate in the big lie, in exchange for their lives.

The International Red Cross representatives arrived at Terezin on June 23rd, 1944. They were met at the city gate by Herr Director Rahm and some SS assistants dressed in casual civilian clothing. Inspectors were shown only what the Nazis wanted them to see: On cue, merry groups of young girls carrying garden tools passed by while singing a song. A fake bakery sold fresh loaves of bread, and a fake vegetable shop displayed actual fresh vegetables- never before seen at the camp. A fake soccer game was played, and beautiful classical music was performed on the square as part of the ambience. Theatrical performances were presented. The lie worked. The International Red Cross apparently found nothing to be alarmed about. Terezin appeared to be a lovely place indeed! How lucky the prisoners were! That evening, the deceived Red Cross representatives dined lavishly as guests of the Nazis at the royal palace in Prague.

The lie continued. Not long after the Red Cross visit, a fake documentary was filmed by the Nazis at Terezin, titled "Der Feurer Builds the Jews a City!" With cameras rolling, and with stunned prisoners directed to enact charming scenes of merriment, the Nazis hoped to have a media devise that could convince the world- and perhaps themselves- that their methods were humane and compassionate. Scenes of swimming contests and picnics were filmed as armed guards stood just outside of the camera view. When the film crew completed the propaganda footage and left the village, all dancing, music and public gatherings were banned. Conditions in Terezin worsened, and as illness and fever spread, thousands died. Bodies piled up at an average rate of 130 a day. Burial became impractical, as rains unearthed the caskets, floating the dead back into the

village. Corpses were ultimately burned. Sick prisoners were shipped away by train.

In spite of the lies, the art would not go away. Through all of this, the artists of the camp continued to quietly document the reality of Terezin. Feeling privileged and emboldened, the artists worked in lavish detail and confident expression to capture the scenes so that there would be a record of the reality. A crackdown on their drawings was finally called. The artists were charged as "ingrates" spreading "horror propaganda". Otto Ungar had produced some of the drawings that resulted in the Red Cross inspection. For these sketches he was especially singled out. Ungar was tortured at the prison in the Small Fortress, his drawing hand purposely smashed and mangled. He later died in Auschwitz, reportedly found with a lump of coal clutched in his remaining hand. With his last energy, he was still drawing, making marks with the coal.

Yet the Nazis still could not erase art in their death camp. They overlooked something.
At the height of the phony presentations for the Red Cross, art workshops were held for the children at Terezin, primarily for show. These children's art classes were taught by a remarkable woman named Friedl Dicker-Brandeis.

Before the outbreak of the war, Friedl had been a student of famed German artist Johannes Itten, and had studied at the world-renown Bauhaus. She had just begun working as a textile designer for professional theatre. In a sane time, she would have found success and notoriety as a member of Europe's dynamic creative community.

Pause for a moment and reflect upon times that your own drive has been tempered and stalled because of a lack of "correct timing." How would you fare if the career you had envisioned for yourself suddenly collapsed? Imagine that your gallery has gone under due to the economy. Or that your theater

funding has expired, or your music career is thwarted. Would your creative power stop? Now go further. What if you found yourself, as a creative artist, in the most vile situation. How would your artistic potential manifest and alter to fight such unthinkable circumstances?

Despite the ending of her professional opportunities and the elimination of her community, Friedl chose to nurture art. It was Friedl Dicker-Brandeis who provided paper, pencils and colors for the children in the village.

She guided them through joyous creative experiences and quietly collected the drawing which innocently recorded the realities of day-to-day life seen through the children's eyes.

It was she who carefully hid the resulting drawings when the Nazis finally came to destroy any visual evidence of the murderous conditions at Terezin.

With faith and resolve, Friedl placed the artwork and poetry created by the children in two suitcases just before she herself was sent off to Auschwitz along with the last group of her young pupils. Of the 15,000 children under the age of fifteen that were registered at Terezin, records show that only a few more than 100 survived. Through Friedl's deliberate care, the contents of the suitcases were preserved.

Thousands of drawings, paintings and poetry from Terezin emerged slowly after the war. They were found hidden in cracks in the walls of barracks, and uncovered after having been buried in containers in the prison courtyards. Each newly-found work added to the growing scope of human experience that unfolded about the people who lived and died within the confines of the ghetto. Because of the art that was left behind, the story of Teresienstadt can be read as a radiant flame in the darkness, a reminder that we should above all feel gratitude and joy for life. The example of courage displayed by the young artists led

by Friedl Dicker-Brandeis has become legendary. The notion that the creation of art could serve as a buffer against evil and a document of vitality of life is fueled by her work. Her challenge to us is simple: nothing is really capable of stopping art, as long as humans who have courage remain among the living. It is a reminder that even after breath has left the bodies of the creators, the resulting works of authenticity can continue to connect us and compel us.

Today, we can imagine the music of Hans Krasa's opera, sounding through the barracks of the camp on frigid evenings. These are the words sung at the end of Brundibar, when the children defeat the wicked organ-grinder:

"We won victory over the tyrant, mean!
Since we were not tearful,
Since we were not fearful."

Art can rise to heights beyond a gallery wall, a theatrical stage or a sanctioned formal venue. Art can rise beyond decay. Art does impact lives beyond market price tags and reviews. Art can serve as humble glue holding us together, or as an overt practice giving hope and meaning.

Artists can prepare themselves to fully recognize and utilize this potential.

*"In teaching, we neglect to sponsor passion
as a discipline. The only discipline we teach
is that of the deadly diagram, supposedly to be
fertilized later by personal experience.
Later is too late."*
—Rico Lebrun, Painter and sculptor

Beyond Technique

Our lives seem to be formed so poetically. Different
ingredients, choices and seemingly "random" events lead
naturally towards an individual armed with the experiences,
wisdom and courage necessary to fulfill their true calling. Yet,
how many of us can face that? How many of us recognize it or
act upon it? Analyzing the life stories of courageous creators
can make it clear for our selves that there are no "accidents",
"mistakes" or "misspent years". In the case of living artists
whom I interviewed, I asked them if they were aware of these
connections and congruities that ran through their lives. All of
them were currently at a point on their path where they were
able to discern their personal life pattern and how it resonated
with a greater meaning. They admitted that they could not
have connected the dots at early stages of their lives, but that
as they grew, they could sense their own purpose. They could
understand the greater meaning that their art played not only
in their own life, but in the world. Every aspect of their lives
connected neatly to the most dynamic destination. This was so
exciting for me.

Don't we all long to experience that understanding? Could this
be the greatest sensation for an artist, the ability to come to
terms with the unifying flow of life?
When in motion, the dancer integrates all that their body
could ever do. All gesture is possible because all layers of past
learning blend into the present to become the full outcome that
is the dance. Musicians blend years of sonic preference with
accumulated discipline and physical practice. Writers develop

135

cadence, style, and the ability to compel with a select arsenal of words, which can flow onto the page. Painters, sculptors and conceptual artists strive for unity, and a personal vision. Performers aim to let go of their self awareness, so that they simply channel energy.

Before these empowered artists reached that enlightened state, they all prepared for it by passing through a very important threshold: They resolved their relationship with mere technique. When artists reach this place of mastery over technique, an affinity with the past and future occurs. Time folds in on itself. Creative people who reach this point of mastery sense that they actually 'meet' their teachers, mentors and the key forces that inspired them. The realm of understanding is intoxicatingly beautiful, yet it signals that the artist stands at a threshold: They can remain as individual figures cloaked in their art, or they may confidently exit the sacred cave, to rejoin and connect with the tribe. The path of the artist is about continual growth. It is akin to being a mountain climber, struggling to reach a towering peak. Just as the peak is scaled, a higher, more majestic one is revealed. Do you remain at the first point, or traverse to meet the new challenge?

A young musician from New York describes his relationship with technique beautifully:
"When I first heard the music of bass guitarist Jaco Pastorius, I was blown away." he says. "I was a kid and I knew almost nothing about music, but I became instantly aware that I wanted to play just like Jaco. He became my bass-guitar hero. I spent years learning how to play. Today I can go back and listen to his recordings and I actually understand every chord structure. I comprehend the phrasing of every solo. I even think I know where he went mentally and emotionally when he played his most intense work. It was weird, but at this point of deep understanding, I was suddenly faced with a greater challenge: It became time to learn how to play like me. I had to

leave my hero behind so that I could become myself. When I did that, when I began to explore my own territory, I came back into contact with the part of me that is true. This took a huge amount of courage. Once I finally crossed that line, I became a real musician."

A young painter speaks about her first exposure to the great Renaissance Venetian portraitist, Titian:
"When I first stood in front of a Titian portrait at the National Gallery in Washington DC, I was stunned. I couldn't move. I tried to get as close as possible to the canvas without the guards yelling at me. My eyes, my heart, my brain were on overload. I had no idea how this artist, five hundred years ago, was able to create the presence of human flesh. I had no idea how he could fuse the layers of paint to suggest light, depth and reality on a flat surface."

Two decades later, the same artist went to visit the same Titian portrait and was taken aback by her matured ability to finally "see" and comprehend the revered painting.

"Of course there was this build-up in anticipation of viewing the painting again. When I saw it, I experienced a flood of emotions, like seeing an old friend. But this time, twenty years later, I was able to discern how it was created in a glance. The values of light, middle range and shadowy darkness, the intensity of the color, the delicate drawing of the features all made perfect sense to me. I had studied these elements of art for years. I had made duplications of Titian's works as exercises. I had even lectured about Titian's approaches, and I had demonstrated them to classrooms of eager students. Now, up close, I could literally read every stroke of his brush. I honestly understood his technique. The veil of mystery was lifted. A calm came over me. Suddenly there was a sharp shift in power as if a spell had been broken. I no longer needed to look to Titan to ask how he did it. This Renaissance master had already made his claim on history. Suddenly a new voice within me challenged:

"So now what? Never mind Titian. What are you going to do?"

Of course the simple steps leading up to such lofty comprehension are just as thrilling, just as celebratory and just as challenging:

A painter learns the basic concept that adding complementary colors side by side creates a certain shimmering effect. A whole new world of possibilities expands as the artist is faced with the realization that they hold a responsibility to explore and make use of this new found power.

A writer pours over their work and finally senses that they use the same patterns too frequently. The act of recognition helps them develop new directions which spark a more natural rhythm and flow. It is as if the writer is starting all over again, but this time is closer to their true aspirations.

A dancer expands their understanding of the human body by coming into contact with a different culture. A sudden insight about body integration helps them to eliminate a weakness or obstacle that kept them from their ideal. This discovery will only become second nature after months and months of practice.

In the diverse twenty-first century, many artists do not necessarily strive for technical mastery. Achieving formal or academic skills is not part of the path chosen by many artists today. Fair enough.. For them, it is the decision NOT to pursue a formal technique that leads them to the same challenge. They still will find themselves dealing with questions of "originality" which invites the same questions of "Now what? What am I going to do?" Rejecting discipline in order to find new expressions of working is a strategic way for creative artists to provoke their own growth. The process of embracing discipline and learning to finally release it is another.
Either way, the thirst for technique as an end to itself must

be vanquished before we can advance. To be sure, the realm of understanding is intoxicating. It is a comfortable plateau. The ease and affirmation that you have been striving for as a student, perhaps for decades, culminates with a new sense of safety and power. When the battle of technique becomes won or resolved in your mind you will become free to finally express your own needs and impulses as an artist. Then, at that very moment, a greater challenge arises:

When you are ready to change the world, you must move on from that comfortable place. You must. In fact, you ought to prepare yourself now to leave that place when you get there. (You can remain there for a while, if you wish. It is nice after all. You worked hard for it. You are allowed to throw a "Now I understand technique and I am ready to transcend it" party). Next morning however, bright and early, plan to kick any lingering guests out. Clean up the place. Go for a brisk walk. Get ready. Something amazing is about to happen to you.

"*To be a warrior is not a simple matter
of wishing to be one. It is rather a struggle
that will go on to the very last moment
of our lives. Nobody is born a warrior,
in exactly the same way that
nobody is born as being average.
We make ourselves into one
...or the other.*"

—Carlos Castaneda, Spiritualist

Transformation

All great innovators left their places of comfort to explore unfamiliar ground. This ability to transform must be experienced and even mastered by those who follow this higher artistic path. You will confront it in your own time and in your own way. It will require the opposite of technique or acquired artistic skill. Instead, it will require faith.

What does the word faith do to you?
It need not be connected to your beliefs about religion. Some of us glow when we discuss faith, while some of us bristle. Either way, at some point along the path, you will be required to have faith. Faith is the belief in the invisible. Maybe you now have faith in yourself and your circumstances but at some point, there will be no clear set of rules or signposts to guide you. Maybe the opposite is now true for you: perhaps you now see no clear signposts, have no faith whatsoever and yet desire direction.

Most of us are raised to follow rules for our own safety. We are taught to obey set guidelines mostly because it is easiest for our caregivers. We grow up believing that the adherence to comfortable formula is simply the proper, time-honored way to approach nearly every aspect of life. Education, marriage, career, finance and social conduct all come with rules given to us by our circumstances of upbringing. Delightfully and ironically, world cultures reserve a special throne of celebrity for a handful of people who disobey rules. These few become the shocking trendsetters, the misunderstood poets, ruthless anti-heroes and

the spiritual prophets. Some of these people fall into these roles by accident. Some have the role created for them by others. For some it is a conscious decision made along the path. In the realm of business matters, it is said that fortune favors the brave. The same is true in matters of art.

Many of us know that the greatest source of fear comes from change which we cannot control. Our lives are always changing when we are young. We are always learning new things, going new places and meeting new people, especially in school situations. At some point though, we settle into places, situations and relationships which feel comfortable. As creative people, we must trust change. Only through change will we transform into something greater than our current selves. When we are ready to change we may begin to change the world. All we need do to begin, is to choose it.
Depending on your life experience, it may be strange to now embrace the idea that you would ever leave a place of comfort. Depending on your individual perspective, this moment of overcoming the restrictions and distractions of technique and complacency may be many years away, or it may already seem long overdue. Perhaps you can sense it coming into reality, just around the corner. You might be rooting for it. In truth, the change could manifest right now. When you decide you are ready, you are ready. You may send the signal to the universe anytime you want to that you are ready to play ball. The conscious realization that you must leave the place of comfort will serve as the first domino for you. Wishing to leave that place for something unknown is the beginning of the great mystical process of transformation.

You have just read how artists in all disciplines experienced this process. This transformation is also described as taking place in the lives of characters from religious writings, fables and mythological stories. Never mind how other humans have interpreted these words before you. Whether with reverence or with a smirk on your face, go ahead and read the sacred texts

of the world's great religions with this transformation scenario in mind. For that matter, go rent some great movies where the main characters transform into a higher version of their previous selves. Become acquainted with this process so that you develop more trust in it.

According to the lessons from these sources, the transformation or calling is typically first met with a response of "Who, me?" It will probably be the same when it happens for you. Or, you might ask yourself "Why me?" Why should you accept this offer to transform? Why should you accept this opportunity which has come through your door? In the beginning, the answer may not be clear. If we believe that these calls to action, these situations which challenge us to embrace faith belong only to a select few players, or that our lot is to only read about the successful exploits of others from the sideline, then we would be accepting a bread crust in lieu of the feast that is rightfully ours. We must believe that the process of changing into a more powerful version of ourselves is not only possible, but that the change will occur in our lives. We must recognize that we are the heroes of the ancient sacred texts and myths. We must believe that we are worthy, capable and deserving of the same inspiration, protection and ability to create as any artist who has walked the Earth before us. We manifest not only pictures, music, sculptures, dances, stories and visions- but also ways for them to successfully impact our audience.

How will that transformation begin? How will that transformation occur?

How will you know that it is happening, for real?

 "Life shrinks or expands
in proportion to one's courage."
—Anais Nin, Writer

Transformation Scenarios

Here is the answer: Once you open up to the ideas of new possibilities, life will present you with a taste of something that provokes you to change.

A transformation scenario will point you towards an opportunity to acquire and explore a new set of tools. Don't think that you must go out of your way to prepare for it. In quiet, unknowing ways you have already been doing so. Just go about your life with a smile on your face, truly expecting at least one of these situations to occur out of the blue:

• You will hear about an idea that sparks a new interest and you will be compelled to listen. You will be reading a magazine, watching television, surfing a website, when you will chance upon an article, story or advertisement that has you intrigued. Maybe it is an idea you heard a thousand times, only now it carries with it a fresh vitality. You will want to learn more. Maybe you were just thinking about a certain subject. Sure enough, someone will present you with more information. It will seem like a coincidence. What ever it is, embrace this idea. **Act on it.**

• Someone offers you a challenge. It will involve you doing something with your art which seems out-of- place. You will feel compelled to try it. An old friend reveals a project that includes you, or a new relationship brings with it an invitation to be a part of something that at first

145

might seem out of your league. This would require you to actively change your usual pattern and develop new skills. Whatever it is, Embrace the challenge. **Act on it.**

• You will be offered a job or an opportunity to do something with your talents that will require you to do the exact opposite of what you have always habitually done. You will be asked to do something with your art that you thought was always someone else's area of expertise. You will have to learn a new skill, fast. Perhaps in the past this skill would have even been viewed by you as not being so important. Now it is urgent. Embrace the offer. **Act on it.**

• You will be invited to work with a group of people you do not normally associate with. Whoever these people are, their philosophy, education background and status will seem unusual to you. Your question might be: Do these kinds of people actually have anything to do with your transformation? Answer: These people will get you frustrated. These people will cause you to have to rethink your approach. These people will surprise you. They will teach you things which you have been avoiding. They will prepare you to handle something incredible in the future. Embrace the invitation. **Act on it.**

• You will be requested to donate your expertise in some way. Without hesitation, you will feel compelled to volunteer. This one is key. Happily swallow the usual expectation of payment. Donate your time and skills. Something wonderful is coming. Embrace the request. **Act on it.**

At first these transformation scenarios might occur quietly and may be nearly unrecognizable, but they will rapidly lead to new ideas and a change of your habits. On the other hand, they might manifest suddenly, with a boom.

Notice how in these scenarios both your heart and mind are being asked to think and feel differently about yourself, your art and even aspects of the world around you. The curious thing about these scenarios is that they are leading to further events that you cannot predict or imagine. You may think you know where they are going, and you may guess that you understand the "lesson" or outcome of these scenarios but events will transpire and reveal their secrets later in ways that will surprise you. Years after the fact, you will be amazed at what the scenarios grew into and ultimately became. In retrospect you will laugh at the way these transforming forces seemed to innocently nudge you into action- maybe without your knowledge- without you even realizing just where you would end up at the time.

These are the beginnings of your new direction. These events should be recognized by you as real signs that you are exactly where you need to be. These are the callings of your destiny. These are the seeds from which you will begin to change the world.

Once presented with these transforming scenarios, how long you toss and turn at night while giving thought to acting upon them is entirely up to you. Here is a word of encouragement however: The sooner you respond to them, the sooner you will embark on your journey. Remember that you are not alone. Others have been on this path before you. Continue to reinforce your understanding by reading the biographies of successful artists, entrepreneurs, spiritual leaders and athletes. Don't get caught up in their celebrity. Try instead to recognize the parallels that you share. It is amazing and validating to identify the moment when these people finally trusted the path enough to actually follow it. Even more intriguing is to recognize times that the universe put them back on their individual path when they doubted it or tried to run away from it. The literary and spiritual symbols of Jonah being swallowed by the whale or Mohammed receiving the word of Arch Angel Gabriel in the cave come to mind.

In a sense this realization erases the fear of "What if I miss my calling?" or "What if I blow that opportunity for transformation when it arrives?" It seems that if a vital connection is meant to happen, you will be attracted to it, and the situation will be repeated or re-offered to you should you miss it or doubt it's authenticity the first time around. You will be presented with chance after chance to transform. Life has a way of naturally nudging us towards our destinies.

Transforming scenarios will begin appearing in increasingly not-so-subtle ways. They will manifest in the forms that you might label coincidence, synchronicity, being in the right place at the right time, or any number of combinations. If it feels as if a train has suddenly appeared at your station with it's doors swung open, It's your cue to jump on board. This is where courage becomes essential. Act from your gut. Embrace faith. Believe in the invisible. It is your train. It is going to take you somewhere different. You will change along the journey. You will grow. Once you agree to a transforming scenario, you are essentially welcoming the forces in the universe that are there to guide you, and protect you. New tools will be born. New resources will materialize, along with new relationships with people in your life. These simple transforming scenarios will take root and begin to spark additional transforming scenarios, which will lead to further new relationships and ideas. This is how a wildfire grows and expands.

Transformation Scenarios

The Defining Event

At some point, because of the alignment of people, places and outcomes of the chances you have taken, a great defining event will occur. The defining event may be shocking or wondrous. It will certainly be linked to the new direction you have agreed to follow in your life. How quickly a defining event will take place in your life depends on your agreement to prepare for it, and your ability to handle it. Your transformation into a more powerful creator will happen as slowly or as rapidly as you can stand it.

As an artist, this defining event will summon your power. The importance and obviousness of a defining event will be measurable. You will be able to look back and "connect the dots" that led up to the event. All the transforming scenarios and their fruit will suddenly link together. You will experience a feeling of "This all makes sense now."

While transforming scenarios will have helped you to explore and create a new set of tools and skills, the defining event will provoke you to proclaim a facet of your true calling.
I shall repeat this: The defining moment will provoke you to proclaim a facet of your true calling.

You will feel incredibly humble and powerful at the same. You will feel connected to the world around you. When you realize the defining moment, you will feel finally vindicated while at the same time you will no longer be concerned with outcome. You will laugh and cry. It will literally be a marker. Afterwards, you will speak in terms of "life before" the defining event, and "life after" the defining event.

ART AND COURAGE

The Test

When you find your voice— when you find your footing and your strength, when you find your calling, the next thing that happens is that you will be tested. At least that is how it will feel at first. Actually, it is your playing field expanding even further than you had estimated. It is an added bonus, a final bite of dessert, just when you thought you were full. It may appear to you that the universe is closing a door on you, when actually it is your golden chance of finding out about your self. "The test" will be unmistakable. When you hit your stride, something will happen that will seem to force you to ask these questions about yourself: How solid is your commitment? How complete is your trust? Of course, everything will turn out fine in the end, but for a time you will be faced with a drama, crisis or twist that will hold a mirror up to you. How you handle yourself, is the point of the test. When you are truly following your calling the test will occur in different forms, over and over again. Each time you emerge from these tests, you will be substantially stronger and wiser. The test is really just a harmless extension of your growth. Do not hold onto any fear, confusion or possible erosion of confidence that it may bring. Stay focused, detach from expectations, and remain on the path that has been revealed to you. Many others have walked this way before.

You will see that everything you secretly hoped for is really true.

bar

Acknowledgments

I sincerely wish to thank the many individuals who contributed to the creation of this book, through their advice, encouragement or friendship:

Professor Saul Bernstein, Sugar Brown, Co-Director of the Koplin Del Rio Gallery, Margaret Danielak, owner of "A Gallery Without Walls", Eleana Del Rio, Director of the Koplin Del Rio Gallery, Spike Dolomite-Ward, Director of Arts In Education Aide Council, Shirley Goins, Director of the National Center for Missing and Exploited Children, Eric Gordon, Director of the Workman's Circle, A Shenere Velt Gallery in Los Angeles,
Teresa Langness, Director of Full Circle Learning, Deanne LaRue, Jack Rutberg, Director of the Jack Rutberg Gallery, Laura Peisner, Martha Perez, Mark Vallen, Stuart Vaughan, Director with the City of Los Angeles Department of Cultural Affairs.

Thanks to Danielle Bewer, Dan Milnor Gonzales, Peter Krauss, Ashley Laurence and Claudia Pedersen for their editorial contributions.

Thanks to George Foster for the cover design
and David Braucher (david@visiontovisual.com) for interior design .

Thank you to my parents and family.
Also to my many students, who teach me so much.

Permissions

Quote by Twyla Tharp, "Without passion, all the skill in the world won't lift you above craft. Without skill, all the passion in the world will leave you eager but floundering. Combining the two is the essence of the creative life" Reprinted with the permission of Simon & Schuster, Inc from THE CREATIVE HABIT by Twyla Tharp with Mark Reitner. Copyright 2003 by W.A.T. Ltd. All rights reserved.

Quote by Rico Lebrun from the book DRAWINGS reprinted by Permission from University California Press. Copyright 1961

Special thanks to Constance Lebrun and the Koplin Del Rio Gallery.

Quote by Carlos Casteneda, from THE TEACHINGS OF DON JUAN- A YAQUI WAY OF KNOWLEDGE. 40th Anniversary Edition, Copyright 2008. Reprinted by permission, University California Press

Excerpt from THE DIARY OF ANAIS NIN 1939-1944, Volume III, copyright 1969 by Anais Nin and renewed 1997 by Rupert Pole and Gunther Stuhman, reprinted by permission of Houghton Mifflin Harcourt Publishing Company

Bibliography

Crow, Thomas, "Emulation- Making Artists for Revolutionary France", Yale University Press, 1995

Green,Gerald "The Artists of Terezin" N.Y Hawthorne Books Inc, 1969

Mina C. Klein and H. Aurther Klein "Kathe Kollwitz, Life In Art" Holt,Rinehart and Winston, Inc, 1972

Brown, Dale and the Editors of Time Life, "The World of Velazquez, New York, Time-Life Books. 1969

Index

About the Author

John Paul Thornton is an artist dedicated to celebrating the human spirit. While teaching art to underprivileged children, he learned that one of his students was reported as "missing". As a way to honor the families who have endured such a loss, John Paul began a series of paintings depicting the faces of America's missing children. Numbering in the hundreds, they have been exhibited in many public installations, most notably on the National Mall in front of the White House, and at the Lincoln Memorial in Washington D.C. His projects for the United Nations' Environmental Programme, have been displayed at the Nobel Peace Center in Oslo, Norway during World Environment Day. He has received honors from CBS Television, the California State Senate and the United States Congress for his work linking art with social causes. John Paul attended Otis Parsons School of Design and California State University at Northridge, where he received his degree while working with two distinct voices in American art: abstract-expressionist Hans Burkhardt and digital painter Saul Bernstein. Extensive travels throughout France, Germany, Austria, Spain, Belgium, The Czech Republic, Holland and Italy have given him the opportunity to study ancient and contemporary Western painting and aesthetics. Invitations to work and teach in Japan, China and Nepal have expanded his knowledge and application of the technical and cultural languages of Eastern art. The Tibetan Government-in-exile in Dharamsala, India granted John Paul permission as an artist and educator to live and work in the Tibetan refugee settlements of Nepal, giving him first hand experience with the traditions and peoples of the Himalayas. This led to the creation of a vast series of paintings exploring the imagery of global wedding ceremonies and sacred religious rituals. His workshops and lectures to audiences around the globe have reached thousands. Thornton's paintings are in numerous private collections. He lives in Los Angeles, California with his wife and daughter.

To view his work, visit www.JohnPaulThornton.com

Find out more, go to www.ArtAndCourage.com

Do you know an artist with a remarkable story?

They could be featured in the next volume of
ART AND COURAGE.

Write us:
jpt@artandcourage.com